THE KLONDIKE GOLD RUSH
PHOTOGRAPHS FROM 1896-1899

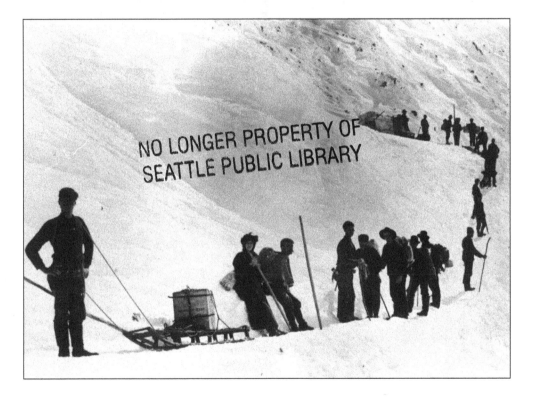

GRAHAM WILSON

Edited by Clelie Rich, Rich Words Editing Services, Vancouver, B.C.
Design and Production by Friday 501 Media Ltd.

Canadian Cataloguing in Publication Data
Wilson, Graham, 1962–
The Klondike Gold Rush: Photographs from 1896-1899

ISBN 0-9681955-0-4

1. Klondike River Valley (Yukon)--Gold discoveries-- Pictorial works. 2. Klondike River Valley (Yukon)--Gold discoveries. 1. Title.

FC4022.3.W54 1997
971.9'1 C97-900361-X
F1095.K5W54 1997

This book is the result of the cooperation and support of many people. The author wishes to thank Emily, Jessica and Coco Wilson for their patience and understanding while this edition was being prepared. Carson Schiffkorn and Miles Prodan helped define this project and gave many important insights. Lloyd Ziff and Stephen Kelemen provided valuable design advice. Ford Colyer from the Yukon Territorial Archives prepared many of the photographs in this book. Karl Gurke from Klondike Gold Rush National Historic Park in Skagway, Alaska, supplied useful information. And finally most of the credit for this book rests with the Klondike Gold Rush photographers who toiled to capture this fascinating period.

FRIDAY 501

Box 31599, Whitehorse, Yukon, Y1A 6L2, Canada
www.friday501.com, info@friday501.com

CONTENTS

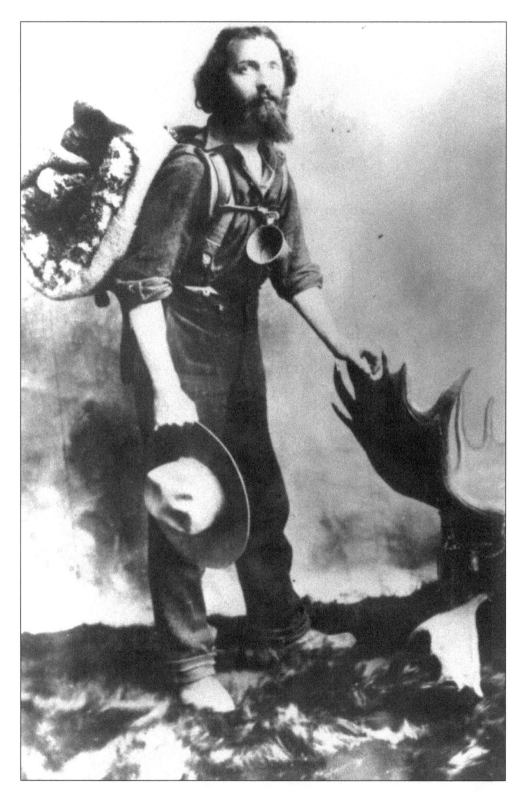

Bonanza!

When the small steamship *Excelsior* docked in San Francisco in July 1897, the world was watching. Aboard this vessel were millionaires who had been penniless men only months before. As these scruffy miners swaggered down the gangplank carrying jars, satchels and cases filled with gold, more than five thousand people crowded the docks and cheered.

A few days later the steamship *Portland* landed at Seattle with sixty-eight miners and almost a ton of gold. The news of the find grabbed newspaper headlines and was on everyone's lips. Overnight, the word *Klondike* took on mythic proportions.

Within days thousands flocked to west coast towns from San Francisco to Vancouver trying to book passage north. The fact that the Klondike was more than fifteen hundred miles away and over a precipitous mountain pass would not deter many. Gold fever had grasped the nation, and everyone wanted the chance to try their luck in the new frontier.

The 1890s was a period of economic depression. Bread lines were long and opportunities few. These were fertile conditions for a gold rush. The Klondike was the hope of relief during a time of worldwide despair and difficulty. The stampede north was an opportunity for the ordinary person and was never exclusively for experienced miners. Fueled by doctors, plumbers, clerks, the poor, the rich, it was everyone's gold rush. Just about anyone could be a stampeder.

A posed photograph of a "typical" stampeder with backpack, taken in a studio.

In the frenzy to move this throng to Alaska, ships were brought in from everywhere. These ships were filled far beyond their capacity in the enthusiasm to reach Alaska. When not enough ships could be found, the most rickety, worn-out vessels were spirited from the bone-yards. The gold would not wait, and stampeders would pay everything they had for passage.

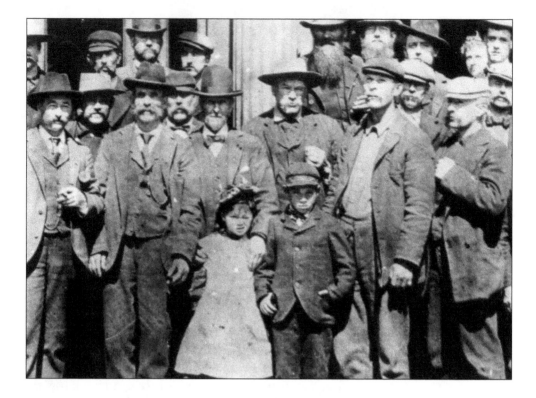

Each miner needed almost a ton of supplies enough to last a year. Everything from dehydrated vegetables to collapsible boats was sold. Warehouses of dried meat, beans and flour were emptied; their contents sometimes auctioned to the highest bidder. The free flow of money and the unimaginable demand for goods attracted a frenzy of suppliers. Since many of the stampeders were inexperienced in both mining and the outdoors, this was also an opportunity for the unscrupulous. Many arrived in Alaska ill-equipped for the northern environment.

As the wealthy veterans of the Klondike bought rounds of drinks in the bars of San Francisco and Seattle, thousands planned their passage to the gold fields. The rush was on. A gold rush like no other.

Above: Wealthy Yukon miners after arriving in San Francisco aboard the steamship Excelsior *in September 1897. The stories of these miners would fuel the excitement about the Klondike.*

Opposite: It was common for ships to arrive encrusted in snow and ice. In the early days of the Rush there wasn't even a wharf leading to the harbors which meant scows had to ferry supplies and passengers to shore.

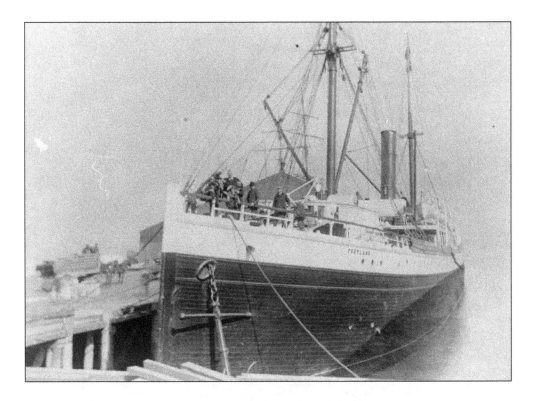

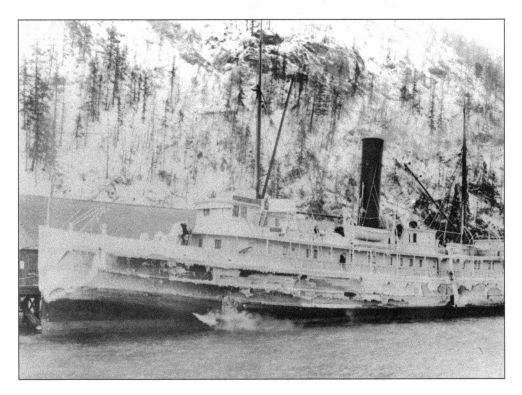

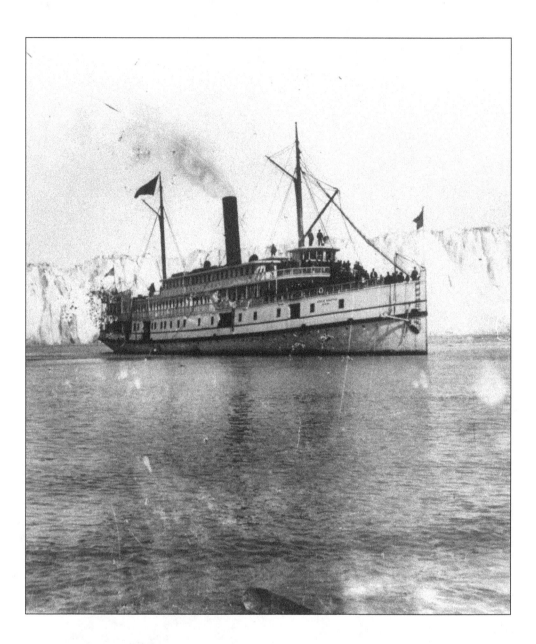

For two thousand miles the vessel steams through land-locked channels, straits, and passages. The landscape is wonderfully beautiful all the way, and the traveler never ceases to wonder at its variety.
William B. Haskell, 1898

Above: Steamship City of Seattle *in Glacier Bay, Alaska, with Muir Glacier in the background.*

Opposite: Schooners beached on Dyea, Alaska waterfront, at sunrise on January 1, 1899.

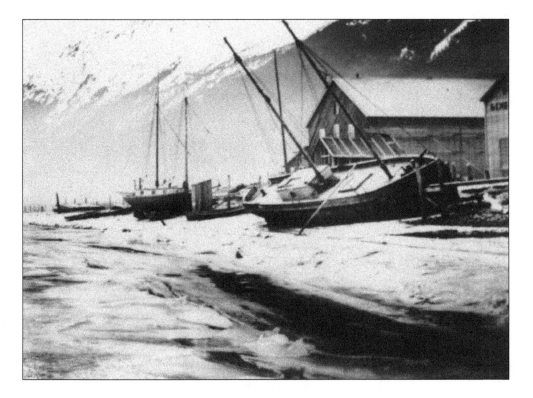

At 3 o'clock this morning the steamship Portland, *from St.
Michael for Seattle, passed up the sound with more than a ton
of solid gold on board and 68 passengers. In the captain's
office are three chests and a large safe filled with precious
nuggets. The metal is worth nearly $700,000 and most of it
was taken out of the ground in less than three months last
winter. The nuggets range from the size of a pea to a guinea
egg. Of the 68 miners aboard, hardly a man has less than
$7,000 and one or two have more than $100,000 in yellow
nuggets.*
The Seattle Post-Intelligencer, July 19, 1897

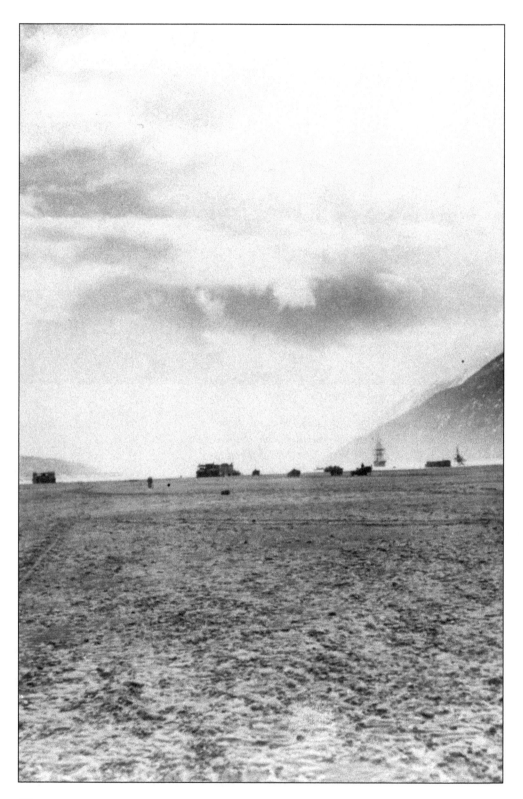

Skagway and Dyea

The towns of Skagway and Dyea sprang almost instantly from the tidal flats of the Lynn Canal. Skagway was the start of the White Pass Trail and Dyea of the Chilkoot Trail. These routes had been well traveled for centuries by Chilkat Indians and climbed past sheer mountains and glaciers. The White Pass and Chilkoot Trails were the most popular routes to the Klondike. For many stampeders this was their first glimpse of the ordeal ahead of them. Some booked passage home, choosing to cut their losses.

In the first couple of years of the gold rush, the city of Skagway was the type of frontier town we see in western movies. It had makeshift buildings with false fronts, gambling halls, saloons, dance halls and bandits. The most notorious outlaw was "Soapy" Smith. His gang of bandits were experienced con men and thieves, many of whom were veterans from other gold rushes. Skagway was an outlaw's haven and Soapy's gang conned, cheated and stole from stampeders at will. Eventually a vigilante group formed to put an end to Soapy's empire. A gunfight followed, leaving Soapy dead, and a short time later his assailant Frank Reid also died.

Dyea was less developed and arguably less lawless, than its sister town Skagway. The first stampeders who arrived at Dyea Harbor found endless tidal flats stretching before them. Ships sat at a safe distance from shore as smaller dories and barges ferried supplies. Those who couldn't afford the excessive cost of having horses or oxen carry their poke above the high water mark faced a dilemma. As the tides advanced, these stampeders had to race madly to get their 1,500 pounds of provisions off the flats.

Dyea tidal flats, with wagons near the water's edge and sailing ships at anchor in the far distance.

Little remains of Dyea today, as it only existed for a single year and was deserted when the White Pass and Yukon Route Railway was completed in 1899. It is still possible, however, to see upright posts in the sand where a pier jutted across the flats to the shallow harbor.

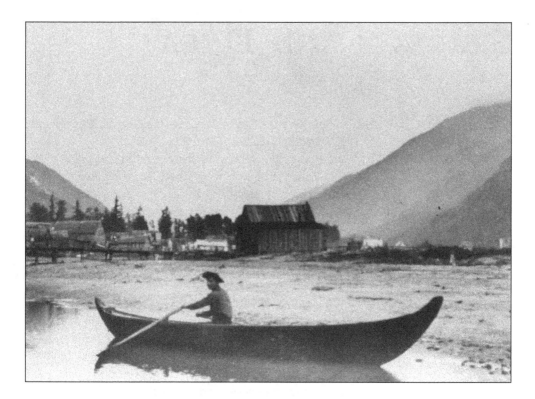

We saw grown men sit down and cry when they failed to beat the tide. Their limited amount of money had been spent to buy their stuff and get it this far. With their flour, sugar, oatmeal, baking powder, soda, salt, yeast cakes, dried potatoes and dried fruits under salt water, and without time or money to replace them, their chances of getting to the gold fields were gone. A terrible blow to the strongest of men.
Monty Atwell, 1898

Above: Partial view of Dyea with a Chilkat Indian canoe on the Taiya River in the foreground. The Chilkoot Pass has been used as a corridor to the interior by Indians for centuries.

Opposite Top: "Chilkoot Jack," a Chilkat Indian Chief, guided many over the Chilkoot Pass to the Yukon. He is pictured here wearing ceremonial dress.

Opposite Bottom: Stampeders on Dyea wharf surrounded by supplies.

Pages 14 and 15: Stampeders amid mountains of supplies landed near the mouth of the Taiya River near Dyea.

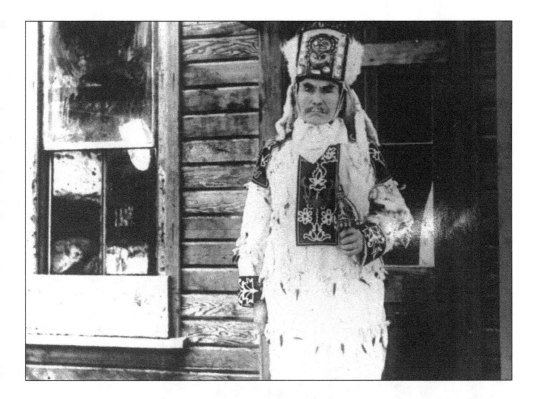

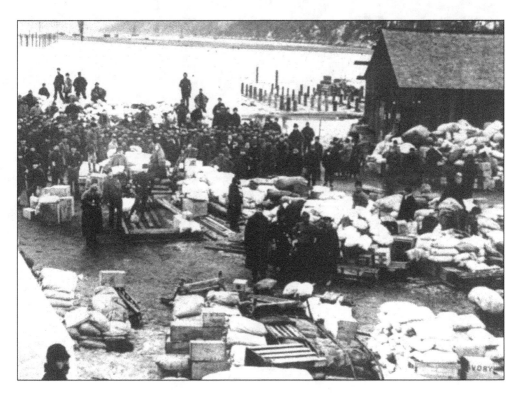

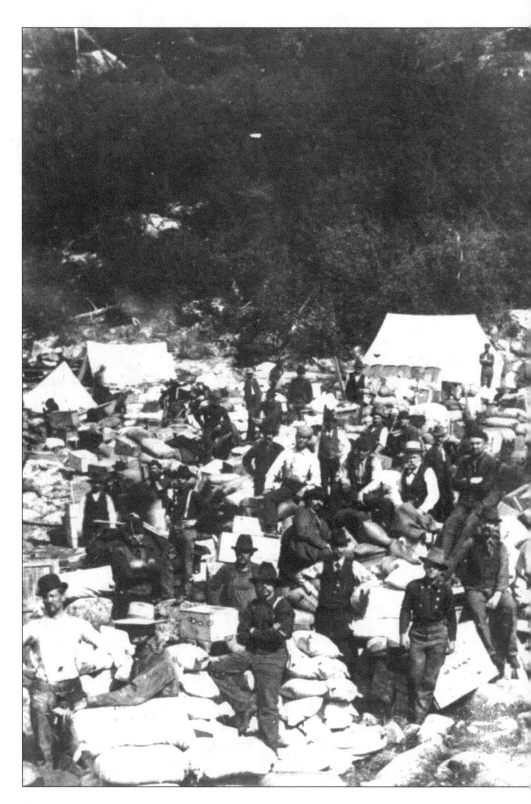

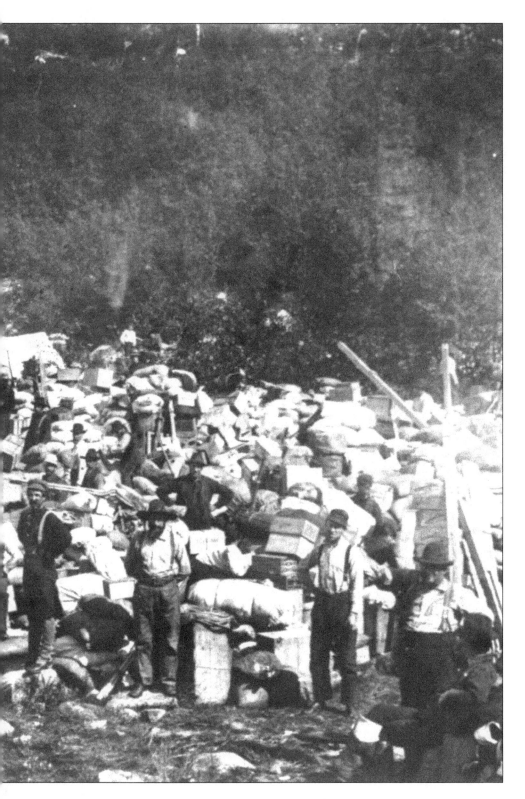

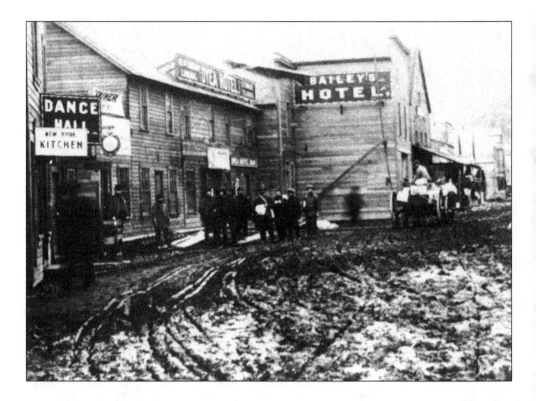

Robbery and murder were daily occurrences.... Shots were exchanged on the streets in broad daylight.... At night the crash of bands, shouts of "Murder!", cries for help, mingled with the cracked voices of the singers in the variety halls; and the wily "box rushers" (variety actresses) cheated the tenderfeet ... in the White Pass above the town the shell game expert plied his trade, and occasionally some poor fellow was found lying lifeless on his sled where he had sat down to rest, the powder marks on his back and his pockets inside out.
Sam Steele, Legendary Mounty, 1898

Above: The muddy mainstreet of Dyea. Businesses along either side are: New York Kitchen, a dance hall, Dyea Hotel, Bailey's Hotel, Yukon Trading Co., and the Klondike Lodging House which offered beds for 25 cents.

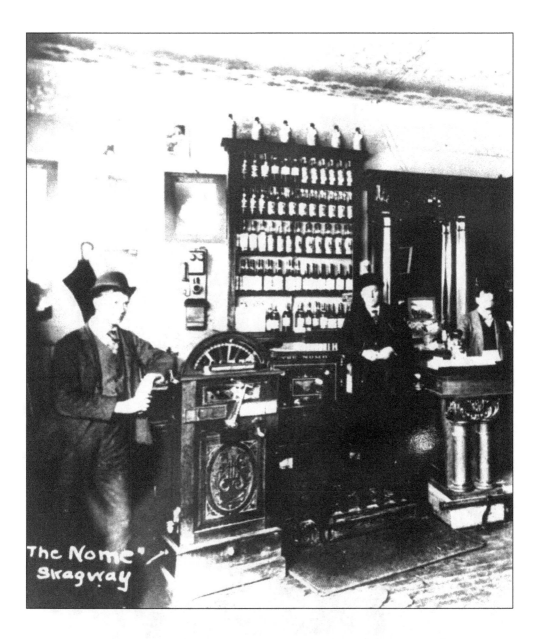

The Nome
Skagway

Above: Nome Saloon in Skagway.

A gambler is one who teaches and illustrates the folly of avarice; he is a non-ordained preacher on the vagaries of fortune and how to make doubt a certainty.
Soapy Smith

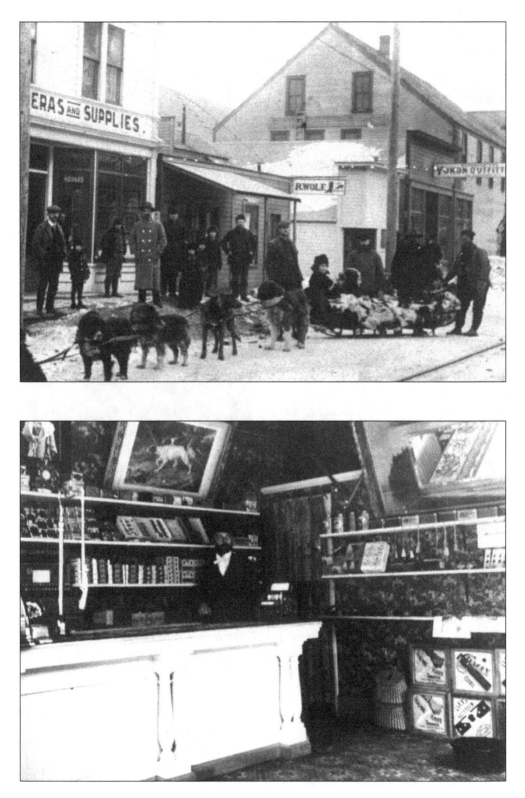

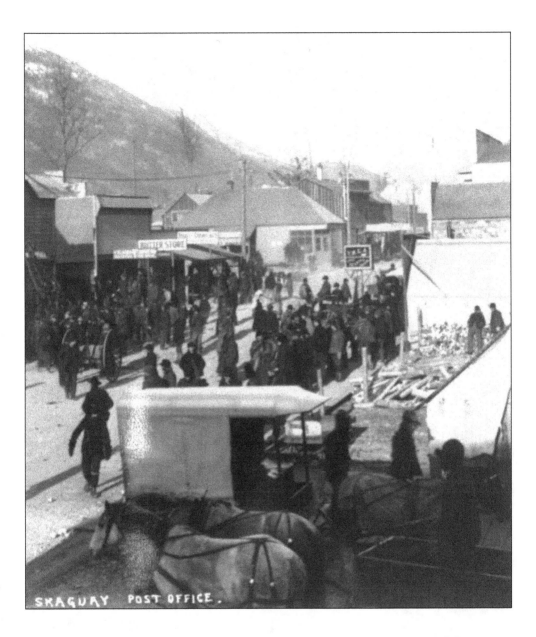

SKAGUAY POST OFFICE.

Above: Crowd on Main Street, Skagway, waiting for their mail.

Opposite Top: Dog team in front of Case & Draper Photography store in Skagway.

Opposite Bottom: Skagway Commissary.

There are more inexperienced men to the square foot than in any place I have ever been to, and more double-action revolvers.
Anonymous stampeder, 1898

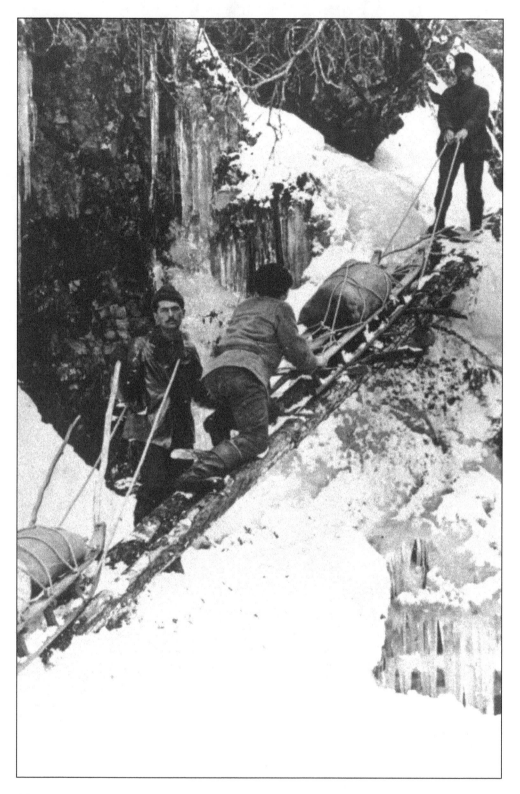

THE CHILKOOT AND DEAD HORSE TRAILS

The barbarity and cruelty of the White Pass Trail is difficult to imagine. This trail led from Skagway through the dense coastal rain forest to a relatively low summit and the headwaters of the Yukon River. The White Pass Trail was about 600 feet lower than the popular Chilkoot Trail to the north but was far more rugged.

The White Pass Trail was a narrow path that followed the Skagway River for much of its course. This path was steep and had numerous sink-holes where horses easily broke ankles and were impaled by stumps. Gold fever drove stampeders to abuse their half-starved horses in the most horrible manner. When the horses dropped from exhaustion or broken limbs, the line of miners and pack animals walked over them until they became part of the trail. For this reason the White Pass became known as the trail of "Dead Horses." It is estimated that as many as 3,000 horses may have died during the first year of the gold rush.

By most accounts the Chilkoot was the preferred trail to the interior. The Chilkoot gained its elevation more gradually and traversed a broader valley. However, the Chilkoot was still a challenging obstacle which sent many stampeders home before even reaching the alpine.

The rugged experience of climbing these passes haunted many stampeders for the rest of their lives. The frequently harsh alpine conditions only exasperated the challenges. To haul the required year of provisions meant stampeders had to relay heavy packs along the trail. By 1900 the White Pass and Yukon Route railway was completed through the White Pass Valley to the city of Whitehorse. Subsequently these trails were abandoned.

Stampeders hauling sleds up "Jacob's Ladder," in a canyon near Sheep Camp.

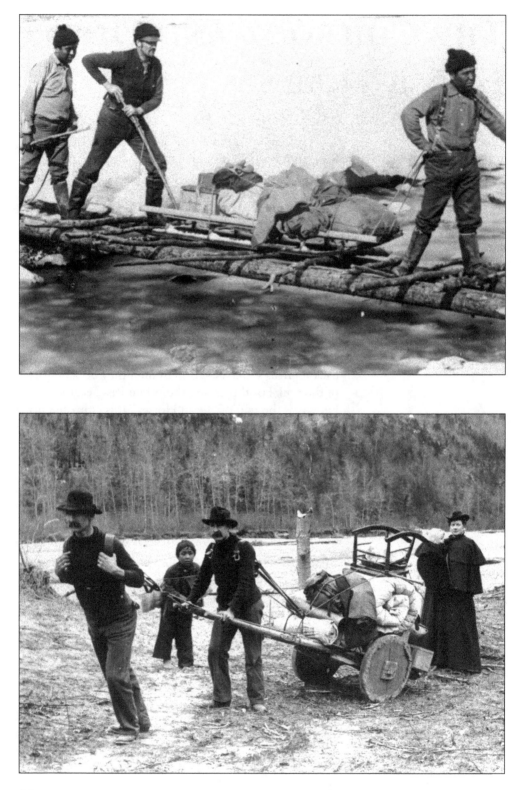

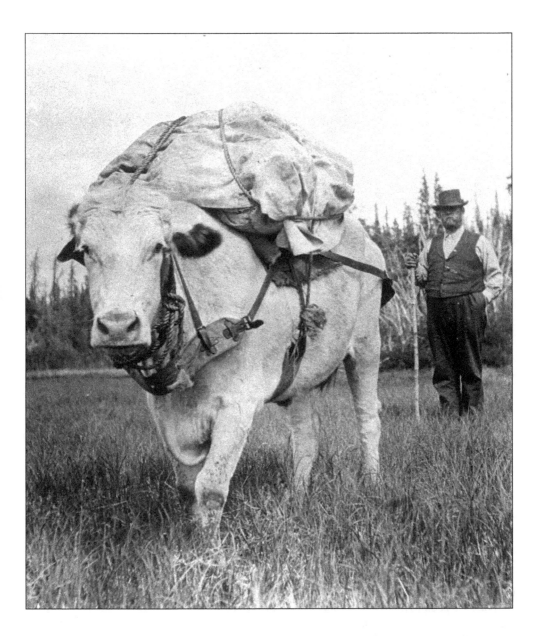

Opposite Top: Two Indian packers with Alaskan photographer Lloyd Winter crossing a log bridge.

Opposite Bottom: Family carrying heavy packs and pulling a handcart at the start of the Chilkoot Trail.

Above: An ox loaded with supplies.

Rain, rain, all the time - no sunshine up in these mountains; tent pitched in a mud-hole, bed made on the stumps of bushes, blankets and everything else wet and muddy.... Even the wood is wet, and will only smoke and smoulder.
Tappan Adney, Journalist, 1899

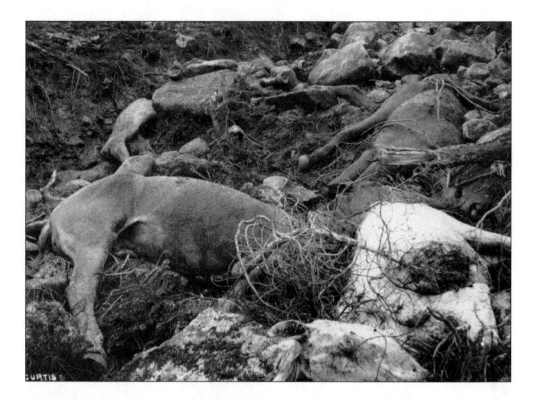

Such a scene of havoc and destruction ... can scarcely be imagined. Thousands of packhorses lie dead along the way, sometimes in bunches under the cliffs, with pack-saddles and packs where they have fallen from the rock above, sometimes in tangled masses filling the mudholes and furnishing the only footing for our poor pack animals on the march—often, I regret to say, exhausted but still alive, a fact we are unaware of until after the miserable wretches turn beneath the hoofs of our cavalcade. The eyeless sockets of the pack animals everywhere account for the myriads of ravens along the road. The inhumanity which this trail has been witness to, the heartbreak and suffering which so many have undergone, cannot be imagined. They certainly cannot be described. *Clifford Sifton, Canadian Minister of the Interior, 1898*

Above: Thousands of horses suffered and died on the White Pass Trail giving this trail the name "Deadhorse Gulch."

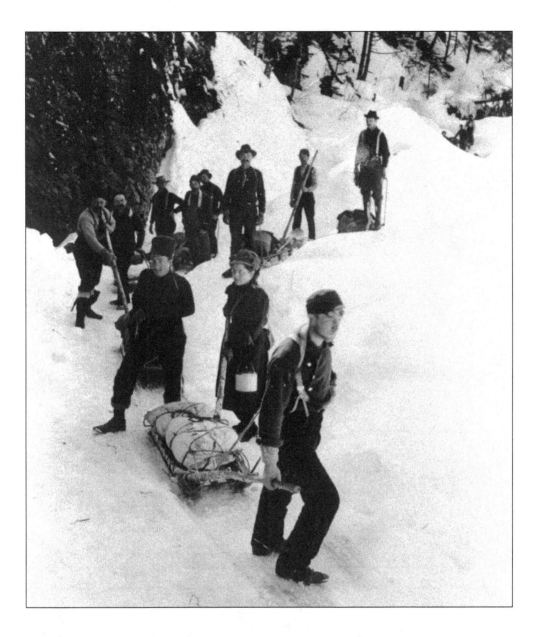

Above: Stampeders pulling sleds along the snow-covered trail.

The trail from Dyea to Sheep Camp, always terrible, was in wretched condition, the entire distance being through snow, slush, and muck, up sharp elevations, down precipitous canyons, and over rocks and boulders covered with snow and ice. Up to the winding canyon the trail crosses one stream sixty-one times....
Emma Kelly, 1898

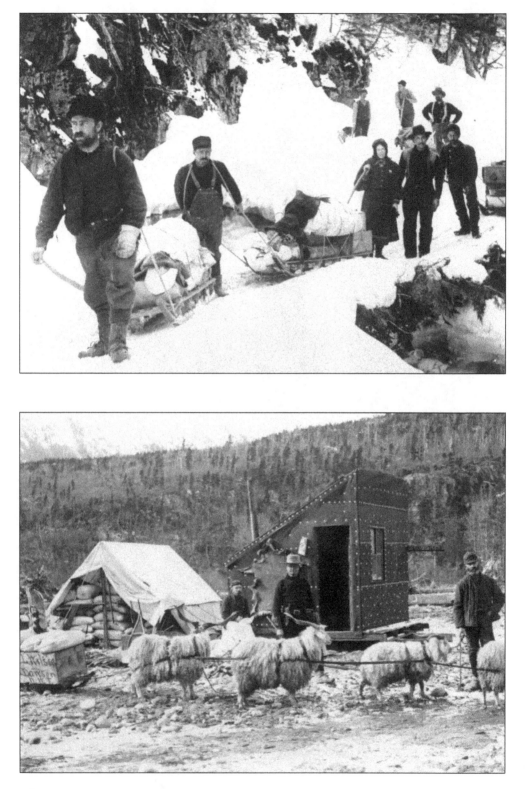

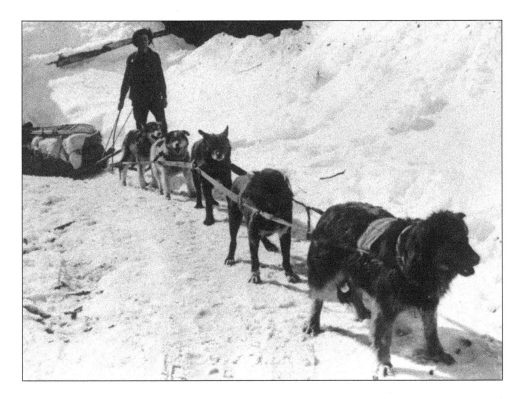

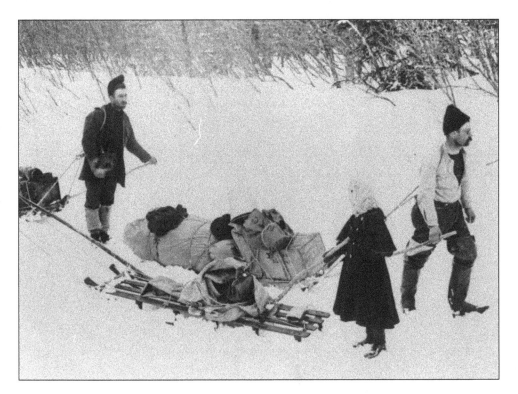

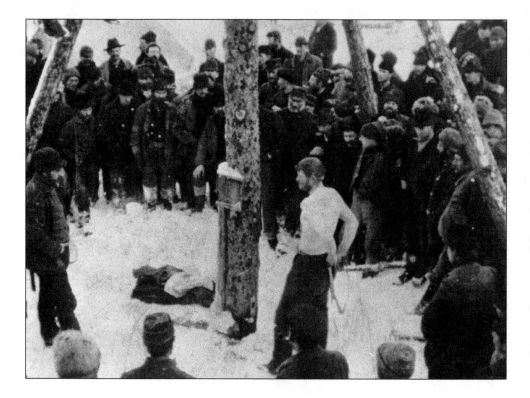

Page 26 Top: Men and women hauling a supply sled over the snow-covered trail through the Dyea Canyon.

Page 26 Bottom: A sled of supplies en route to the Klondike being pulled by a team of goats.

Page 27 Top: Pack train view of two men with their dog-pulled sled on the trail.

Page 27 Bottom: Stampeders and children pulling their sleds along the snow-covered Dyea Trail.

Above: Trail justice could be brutal and swift. Since there were no police along much of the trail, small ad hoc "committees" were formed when needed. There is a tradition of this form of justice in many mining camps, particularly in the US. On the White Pass one committee passed judgment on an accused thief and hanged the man. The man above was whipped and banished from the Klondike.

Opposite: Many stampeders formed small "Pack Trains" to cope with the rigors of the Chilkoot. The trail exacted an incredible psychological and emotional toll on the stampeders. Many would later recount that it was the most challenging thing they had ever done.

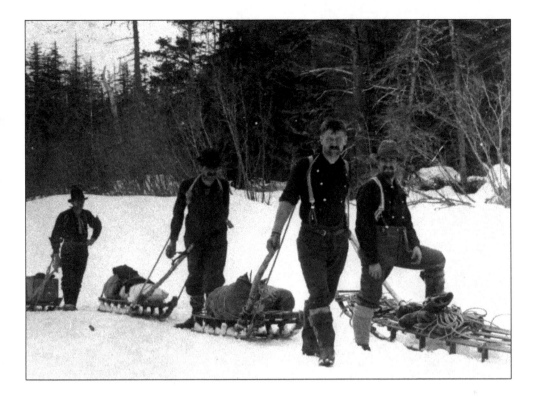

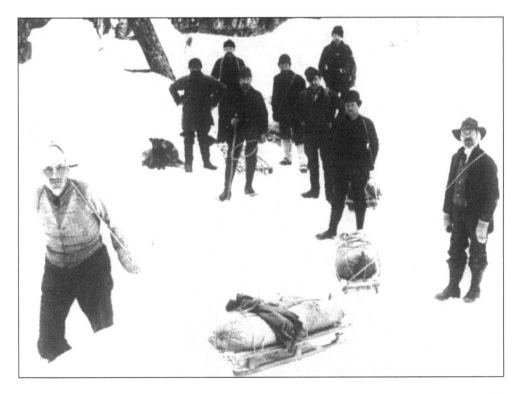

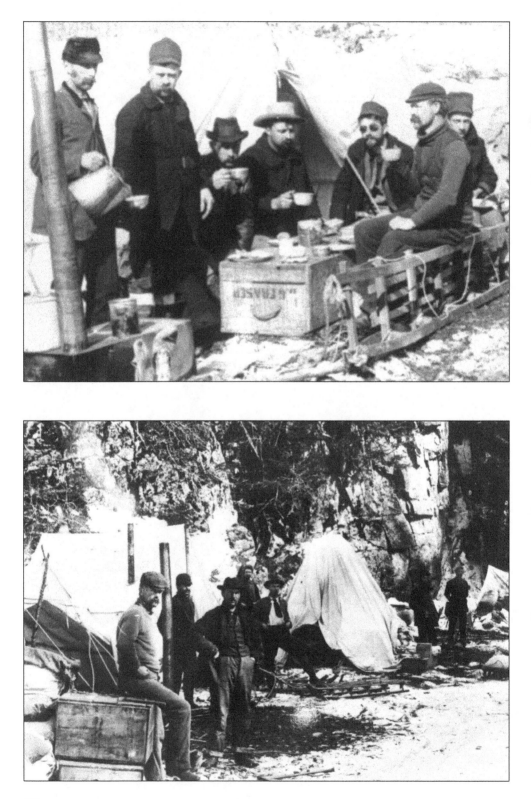

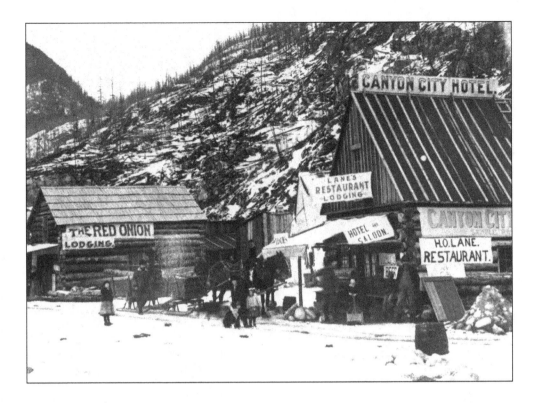

Above: Canyon City was along the Chilkoot Trail. A horsedrawn sleigh waits between the Red Onion and Canyon City Hotels.

Opposite Top: Stampeders enjoying dinner along the trail.

Opposite Bottom: Stampeders in front of their caches and tent camp in a canyon along the Chilkoot.

In my memory it will ever remain a hideous nightmare. The trail led through a scrub pine forest where we tripped over bare roots of trees that curled over and around rocks and boulders like great devilfishes. Rocks! Rocks! Rocks! Tearing boots to pieces. Hands bleeding with scratches. I can bear it no longer. In my agony, I beg the men to leave me—to let me lie in my tracks.
Martha Black, 1898

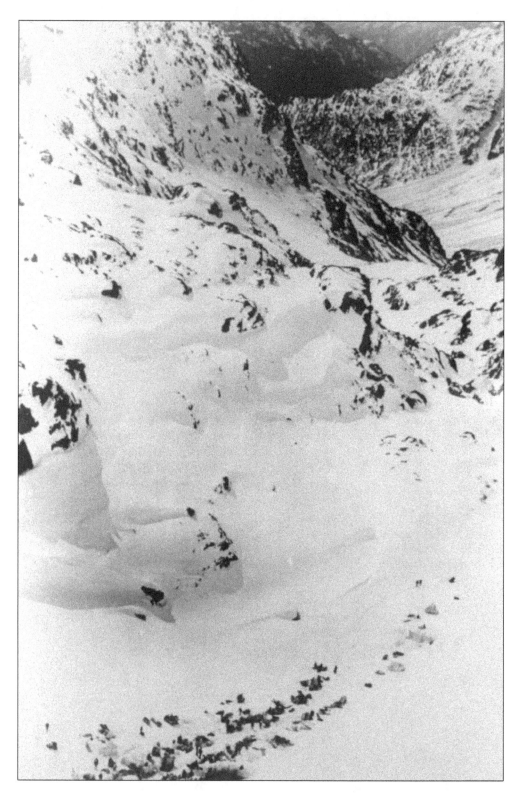

THE GOLDEN STAIR

The most memorable image of the Klondike Gold Rush is that of a line of stampeders climbing the Golden Stair. The throng of anxious stampeders toiling under their enormous packs and cases underscores the grim reality of their undertaking.

In total the Chilkoot trail is thirty miles in length and climbs 3,500 feet. The first third of the trail winds through coastal rain forest. The trail continues to climb gradually until it reaches Sheep Camp at the base of the Chilkoot Pass. From here to the summit the trail gains more than two thousand feet in elevation in less than ten miles.

The final push to the Chilkoot summit is a thirty-degree slope. This is the Golden Stair. In all seasons, snow slopes and steep ice cover this rocky gain. The Golden Stair had fifteen hundred steps cut into it, with a single icy rope to clutch to. Once a man stepped out of line, it could take him several hours to rejoin the trudge up the mountain.

Each stampeder carried almost a ton of provisions and supplies over the Chilkoot. This required each person to make an average of twenty to thirty trips along this trail. The wealthy could hire Indian packers or later in the rush use the tramway to carry supplies. Most stampeders simply put their heads down and grunted their boxes, bags and satchels over the pass. Many took several months to complete the Chilkoot.

A birds-eye view of the daunting Chilkoot Pass in winter. Stampeders, tents and caches of supplies can be seen at the bottom.

The worst season to be in the pass was during the winter as sub-zero temperatures, high winds and blizzards stopped many in their tracks. The winter of 1897 – 98 was particularly harsh with more than 70 feet of snow accumulating on the summit of the Chilkoot. Overnight entire communities of tents and supplies were buried under mountains of snow The Chilkoot was a dangerous place where horrible suffering was a daily reality. The worst disaster occurred on April 3,

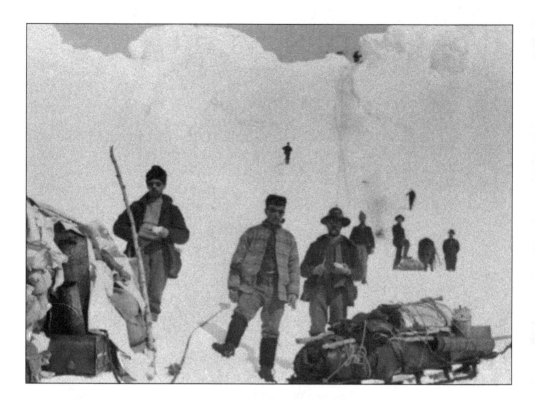

1898, when an avalanche claimed more than 70 lives.

Other snowslides also took lives. Creeks could flash-flood and take away a year's supplies in seconds. One flash flood drowned three men. The Chilkoot was a brutal, unrelenting pass, but it happened to be the best choice for accessing the interior.

The North West Mounted Police claimed the summit as Canadian soil and established a post. To maintain order, a Maxim machine gun was brought to this rag tag collection of canvas tents. The Mounted Police adopted the policy of turning back the ill prepared and charging a duty to bring supplies into Canada.

From the Chilkoot summit to Lake Lindeman, the trail is entirely downhill. For most, simply dragging their supplies downhill was a welcome relief from the rigors of the Chilkoot.

Above: Stampeders with a huge pile of gear preparing for the ascent to the Chilkoot Summit.

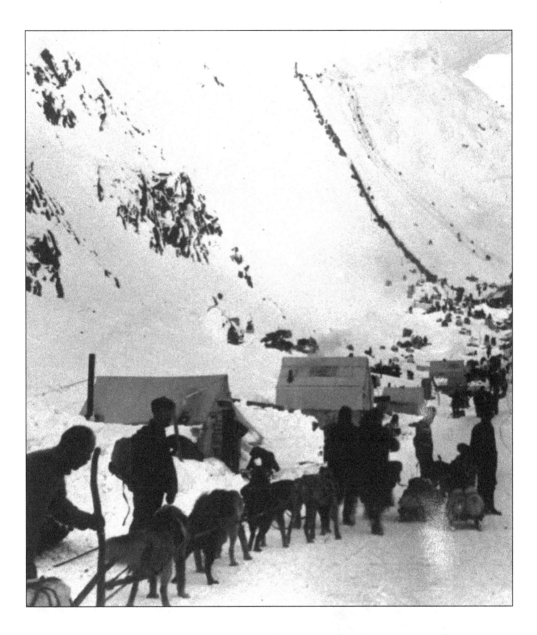

Above: Stampeders and loaded dog sleds descending the trail to the scales. A steady line of men ascends in the center of the photo. Caches of supplies, tents and men blacken the snow covered resting site.

The story of the trail will never be written by one person. It is a series of individual experiences, each unique, and there are as many stories as there are men on the trail.
Tappan Adney, Journalist

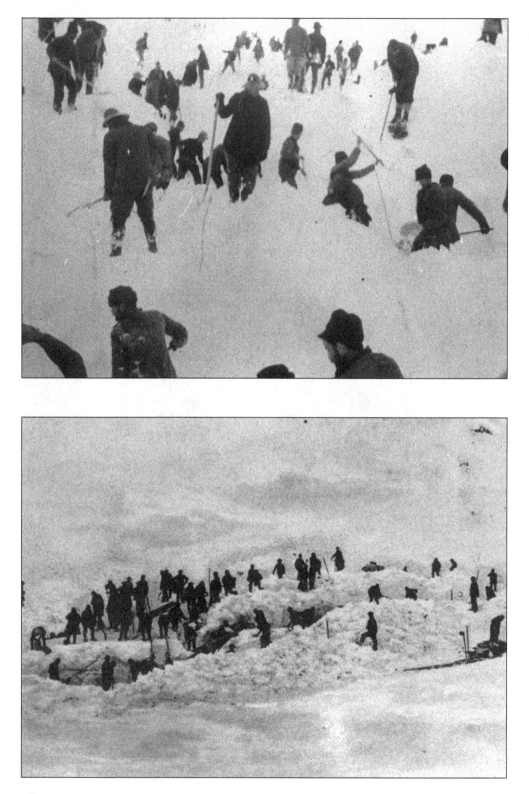

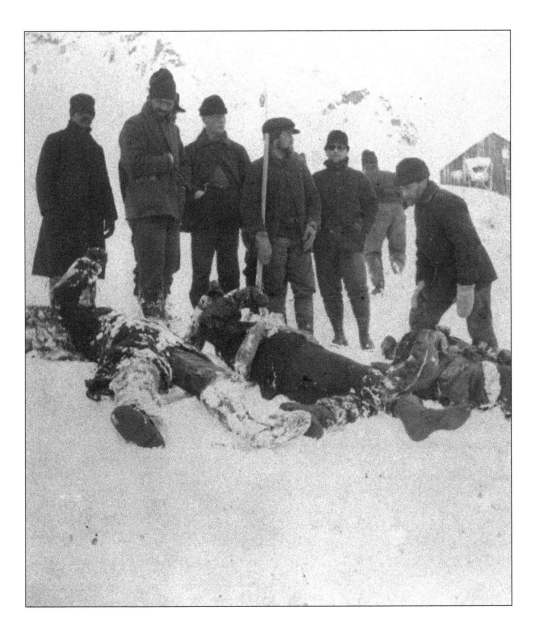

Above and Opposite: On April 3, 1898, a massive avalanche swept from a slope 2,500 feet above the Chilkoot Trail. Within seconds the trail was buried under tons of snow, ice, rock and debris. Hundreds raced to dig for survivors. In total 70 men perished.

This disaster has decided many who were hanging in balance. Whether they have lost their outfits or not, it has given them a good excuse to go back. From this time on only the strong-hearted continue on their way.
Tappan Adney, Journalist, 1899

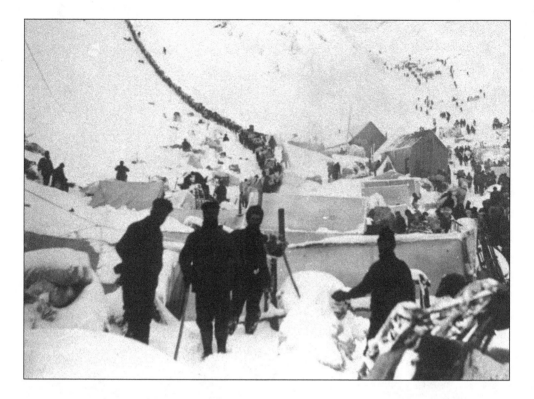

There is nothing but the gray wall of rock and earth. But stop! Look more closely. The eye catches movement. The mountain is alive. There is a continuous moving train; they are perceptible only by their movement, just as ants are. The moving train is zigzagging across the towering face of the precipice, up, up, into the sky, even at the very top. See! They are going against the sky! They are human beings, but never did men look so small.
Tappan Adney, Journalist, 1899

Above: Panorama of final ascent of the Chilkoot Pass showing stampeders and supplies awaiting their turn.

Opposite Top: Line of stampeders ascending the Pass with tents and caches in the foreground.

Opposite Bottom: Stampeders standing beside their caches ready to take the next load over the Pass.

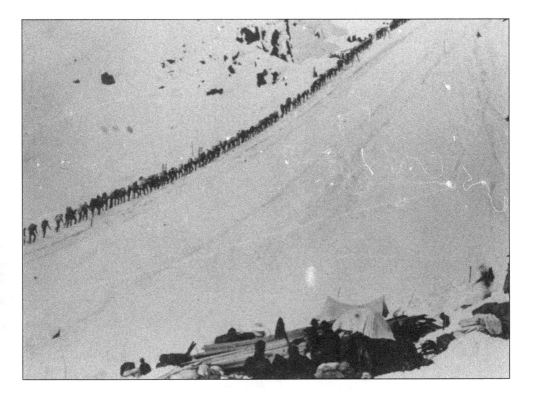

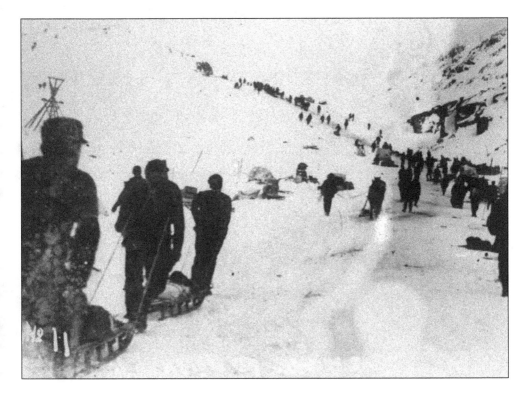

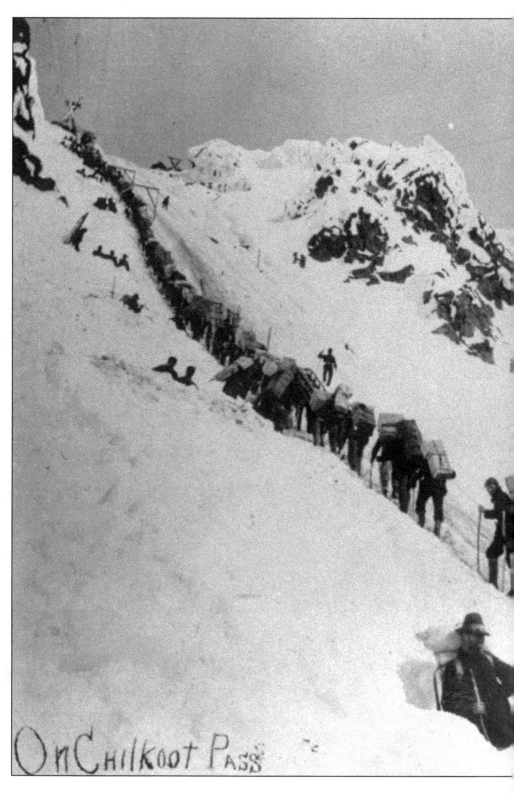

On Chilkoot Pass

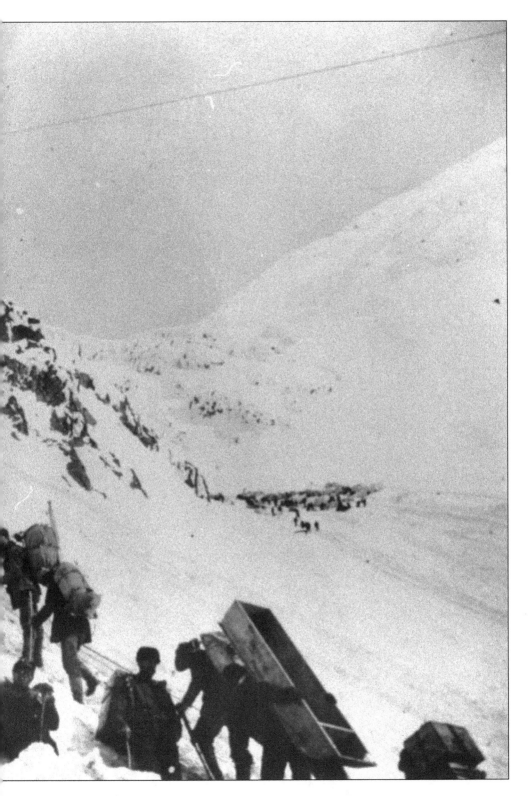

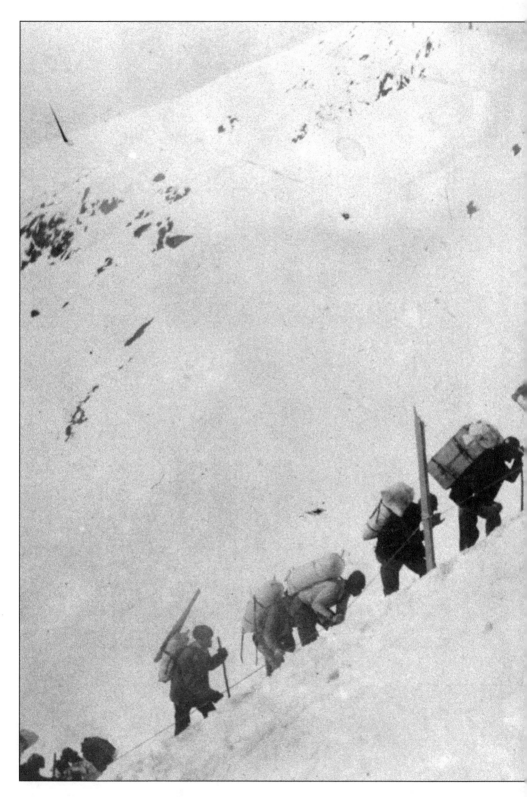

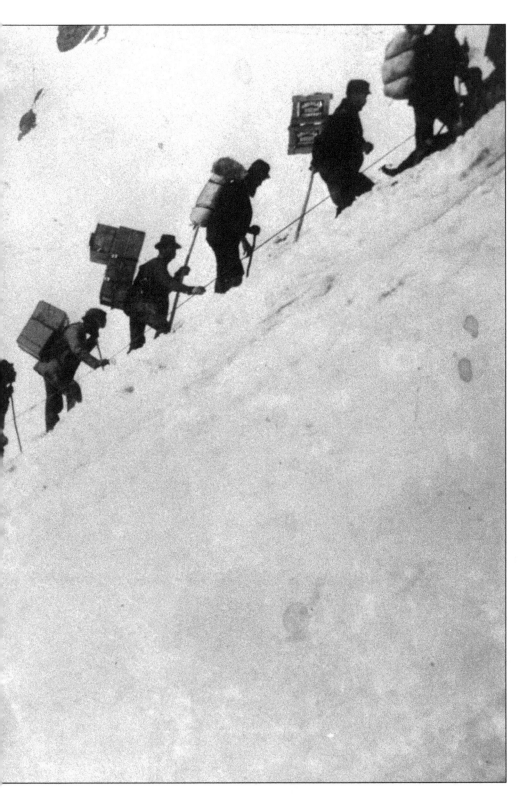

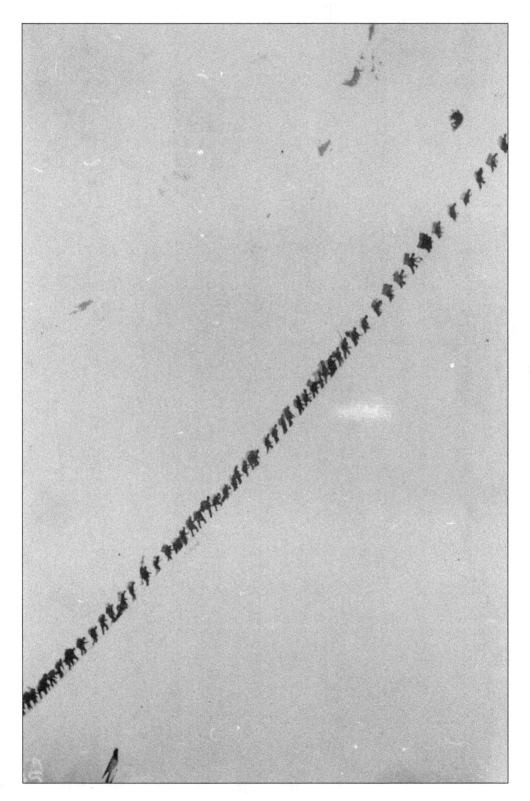

44

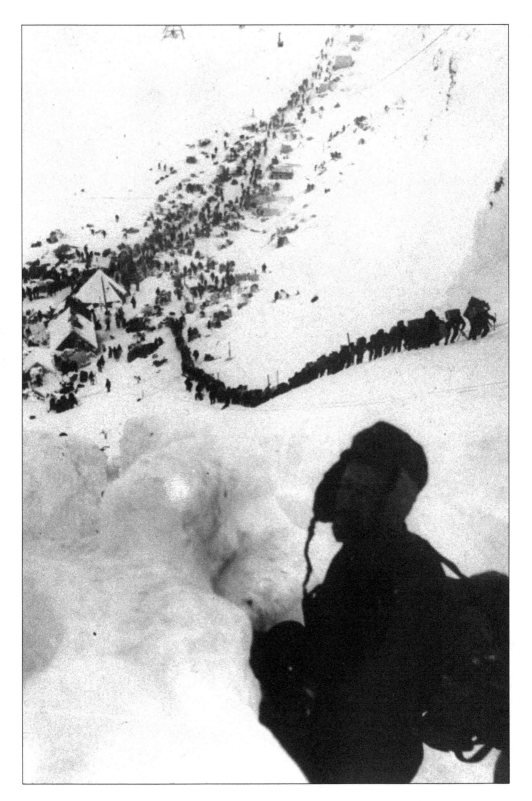

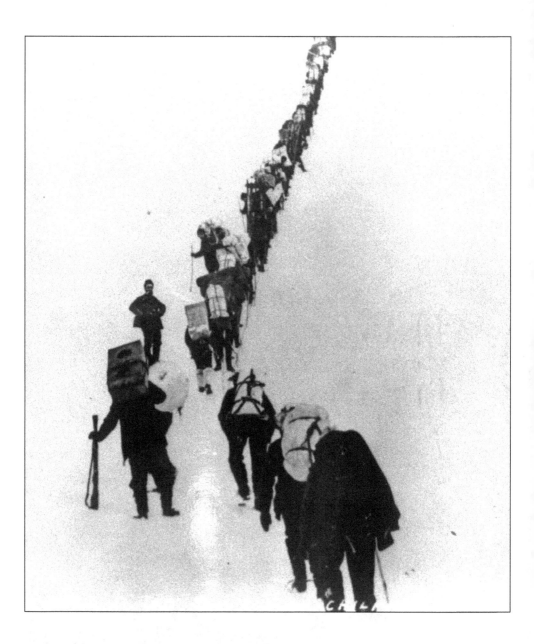

Pages 40 and 41: Stampeders ascending the Chilkoot summit singe file.

Pages 42 and 43: Famous photograph of stampeders climbing the "Golden Stair" to the Chilkoot summit.

Page 44: Stampeders form a thin black line as they struggle up to the summit of the Chilkoot.

Page 45: A view looking down from the Chilkoot summit. A stampeder is getting ready to slide down in one of the grooves worn in the snow.

Above: A line of stampeders weighed down with backpacks on their final thirty-degree climb to the Chilkoot summit.

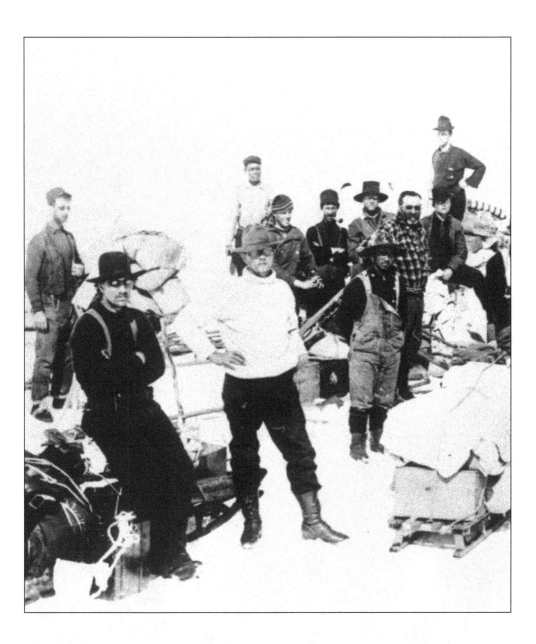

Above: A group of stampeders with loaded sleds and caches of supplies on the Chilkoot summit.

It is the inexperience of those who are trying to go over. They come from desks and counters; they have never packed, and are not even accustomed to hard labor.
Tappan Adney, Journalist, 1899

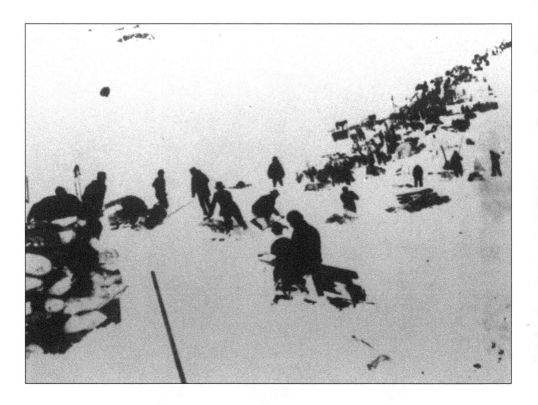

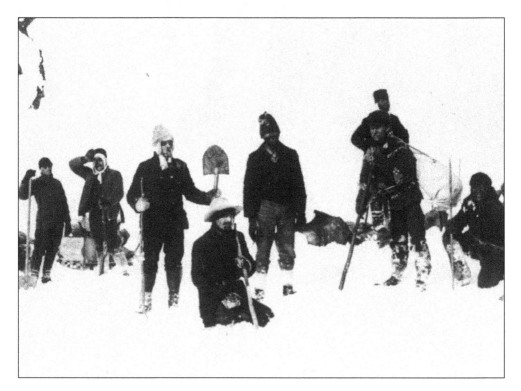

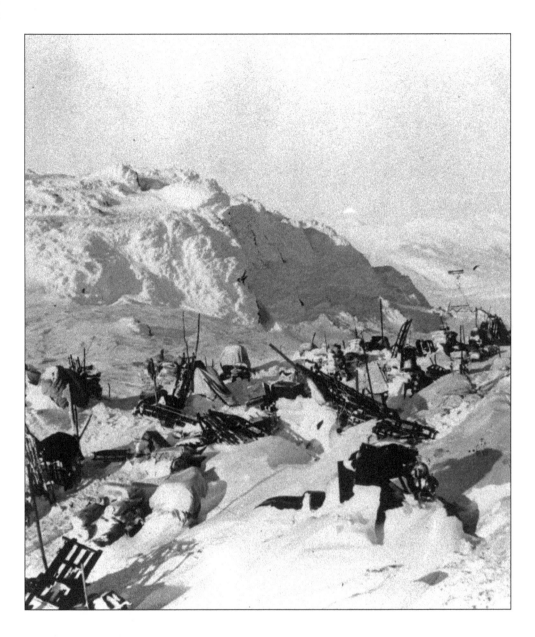

Above: The frozen summit of the Chilkoot was cluttered with supplies. Blizzards frequently buried stampeders' caches under several feet of snow overnight.

Opposite: Stampeders resting at the summit.

Once on top, the trail crosses a broken yet comparatively level summit, over one or two dirty glaciers, and then downward three or four hundred feet of easy pitch to the head of a steep glacier.

Tappan Adney, Journalist, 1899

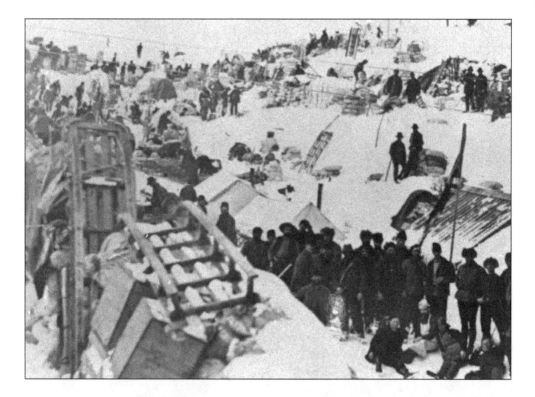

Next day it begins to storm adown the valley—such a storm as I never saw before. It blows until it seems as if the tent, which is held down by heavy rocks on the guy-ropes and the edges of the tent, would be taken bodily and thrown into the lake.

Goods have to be piled end-ways to the wind or else be blown over. The storm continues for several days, with wind, snow, and rain, the sun shining clear each morning through the rain.

Tappan Adney, Journalist, 1899

Above: Stampeders wait amid piles of supplies and equipment to be checked through Canadian Customs at the summit of the Chilkoot Pass. The North West Mounted Police checked each stampeder to ensure he had enough supplies to last a year. The Police also collected duty as well as fulfilling other administrative functions.

Opposite Top: North West Mounted Police and stampeders posing in front of their tent on the Chilkoot summit amid piles of gear waiting to be checked through.

Opposite Bottom: Tent camp at Chilkoot summit.

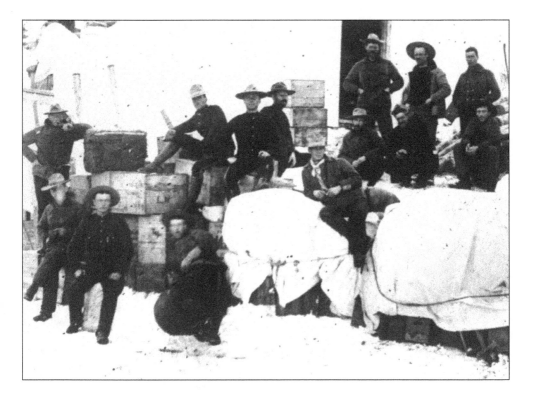

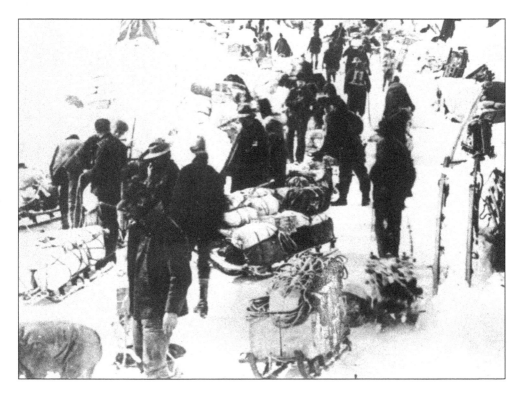

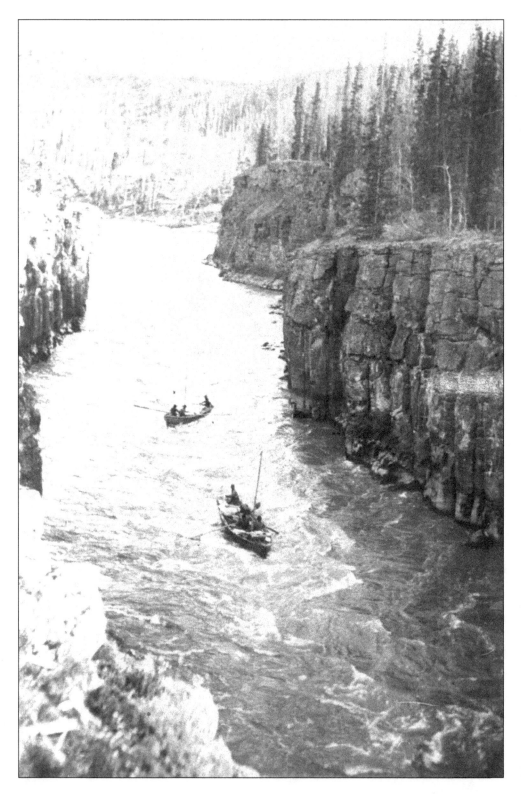

Paddle and Pray

Once over the Chilkoot Pass, the stampeders were still a long way from the gold fields. Boat-building towns were established on the rocky outcrops surrounding Lakes Lindeman and Bennett. During the winter of 1897-98 more than 20,000 people with little or no experience built 7,000 boats.

The landscape was stripped of its trees for firewood and planking for boats. The whipsawing of dimensioned lumber was the most onerous task of building these boats, and many parties split up as a result of fights in the saw pits. Once enough lumber was sawed, crude little boats were tacked together. The sound of oakum hammers filled the valley.

On June 3, 1898, the ice finally went out, and the most rickety armada ever seen set off for Dawson. The progress on the frequently windy and choppy lakes slowed many, but once on the Yukon River a swift current made up for lost time.

The most difficult rapids began at Miles Canyon, near present-day Whitehorse. Stampeders tried to find a route through a long series of waves in the steep-walled canyon. In the week after break-up, more than 150 boats were destroyed and at least ten men drowned. A short time later a tramline was built to haul boats and gear around this rapid. River guides also offered their services, and many of these guides were credited with more than a thousand safe passages.

Stampeders running treacherous Miles Canyon.

The remainder of the trip down the Yukon River was technically less difficult, although white water such as Five Finger Rapids deserved careful consideration. The race to the Klondike was on, and in the midnight sun the stampeders paddled around the clock.

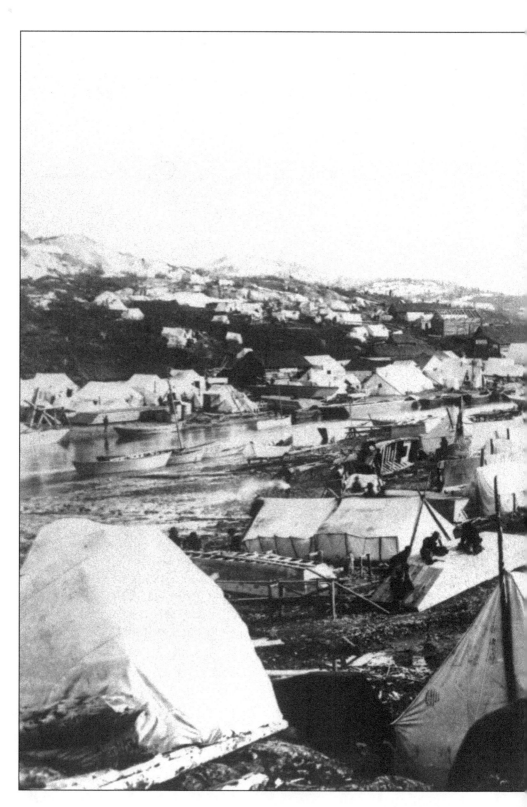

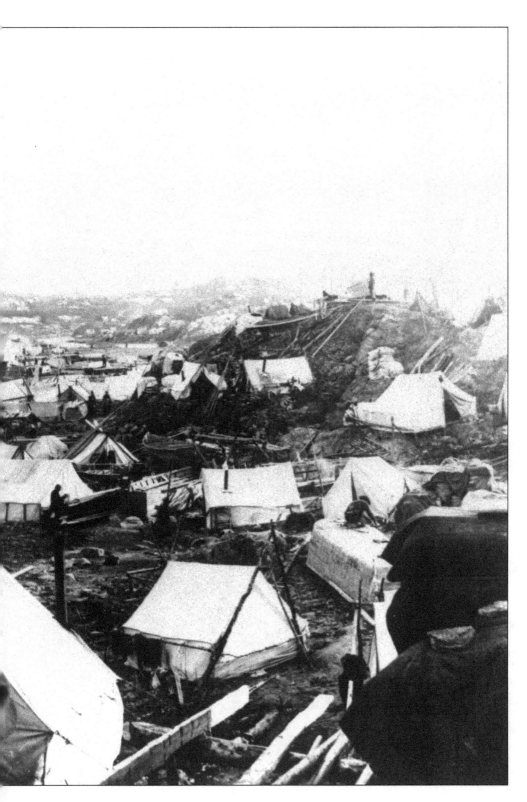

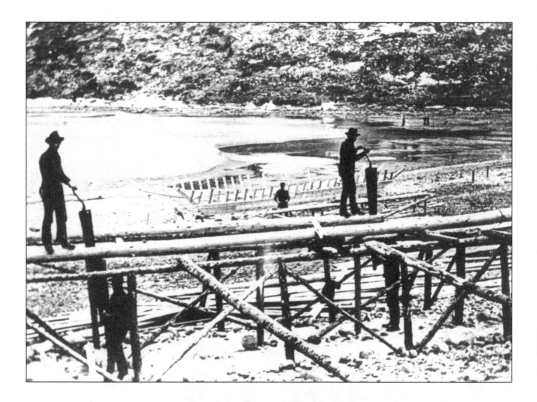

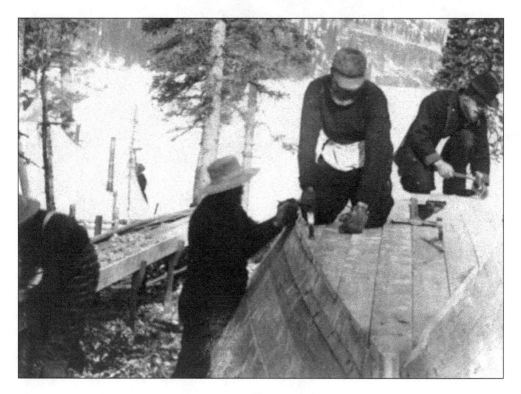

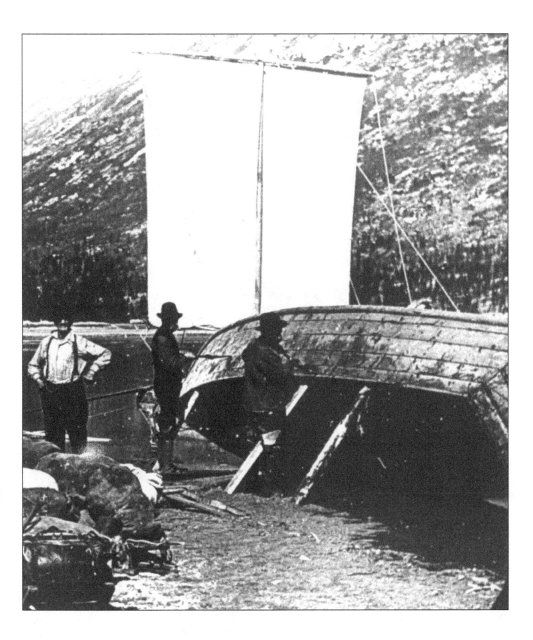

Page 54 and 55: Boat-building among the mass of tents on the shores of Lake Bennett during the winter of 1897-1898.

Opposite Bottom: Flat-bottomed boats were commonly built due to their relative ease of construction.

Opposite Top: Four men whipsawing logs into lumber for boats. The keel and ribs of a boat under construction is in the background.

Above: Caulking the seams was one of the many laborious tasks of making a boat.

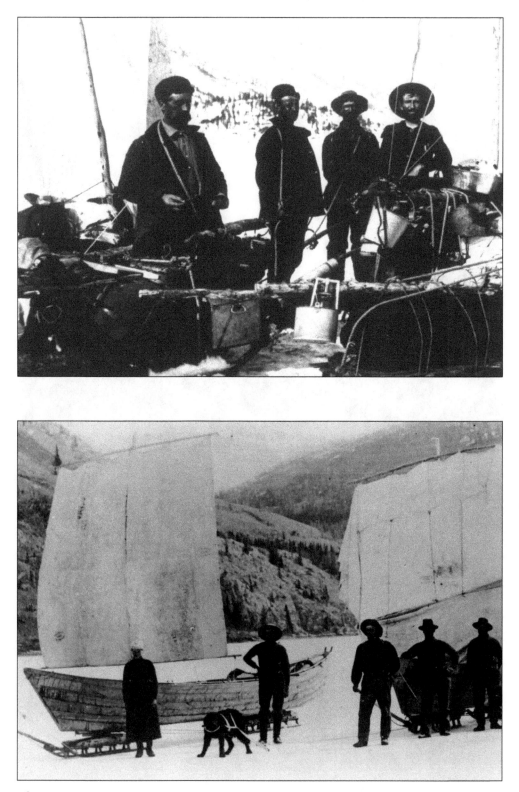

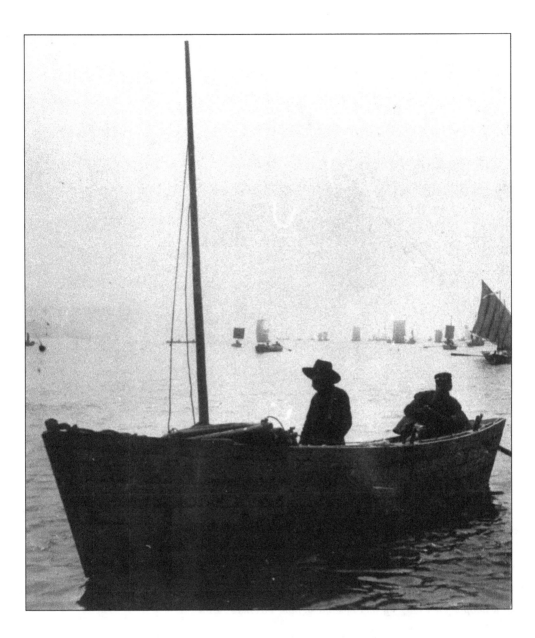

Above: Flotilla of stampeders' boats sailing north to Dawson.

Opposite: Eager stampeders on ice covered Lake Bennett with sails attached to their supply-laden sleds and boats and rope harnesses over their shoulders for towing.

In the morning, however, there is not a breath if air to disturb the surface of the lake. Al's good strong arms send the boat along in the good "ash" breeze, the water is so still that it seems as if the boat were suspended in the air. The sight of this mirror-like surface, with bold headlands of rounded gray limestone, patched with groves of small dark spruce, is truly impressive.
Tappan Adney, Journalist, 1899

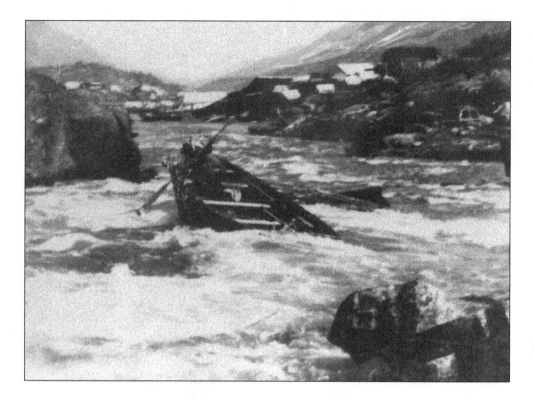

Following the roughest water, to avoid rocks, we are soon in the dancing waves and pitching worse by far than in the Canyon. As we jump from wave to wave, it seems positively as if boat and all would keep right on through to the bottom of the river. The water even now is pouring in, and it is plain that the boat will never live through. One thought alone comforts us: the fearful impetus with which we are moving must surely take us bodily through and out, and then - we can make the shore somehow. I count the seconds that will take us through.

The effect to the eye, as we enter the great white-caps, is that of a jumping, not only up and down, but from the sides to the middle.

Now we are in. From sides and ends a sheet of water pours over, drenching Brown and filling the boat; the same instant, it seems, a big side-wave takes the little craft, spins her like a top, quick as a wink, throws her into a boiling eddy on the lift—and we are through and safe, with a little more work to get ashore.

Tappan Adney, Journalist, 1899

Above: A stampeder's boat is swamped in "1 Mile Rapids," a short stretch of white water between Lakes Lindeman and Bennett.

Opposite: Stampeders running "1 Mile Rapids." It was common for boats to have tents built on the deck of the raft to protect supplies and to provide a place to sleep.

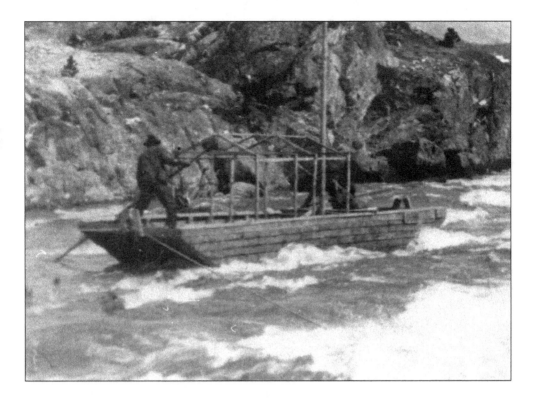

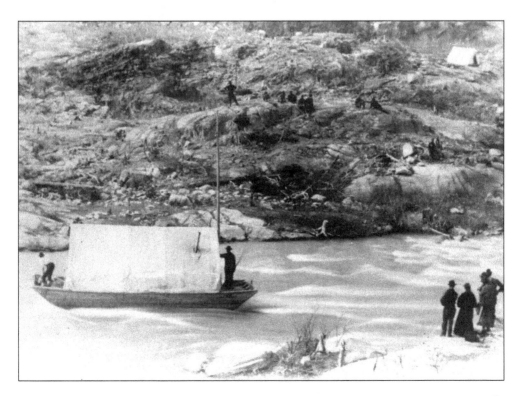

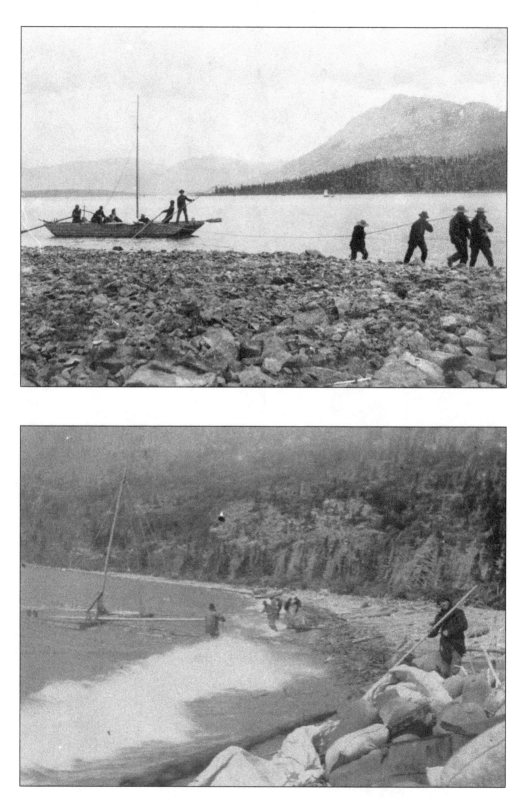

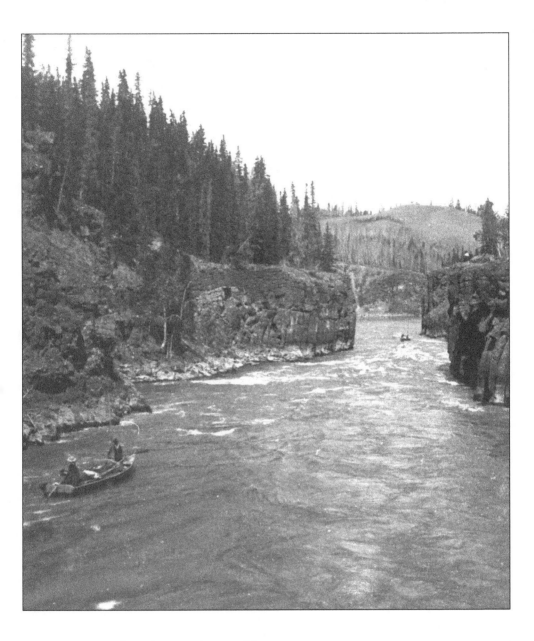

Opposite Top: Men pulling a boat by rope from shore while the men in the boat help with poles on Windy Arm, Tagish Lake. Other stampeders' boats are barely visible on the lake.

Opposite Bottom: Stampeder standing beside a pile of supplies salvaged from a wrecked barge.

Above: Small boats running treacherous Miles Canyon.

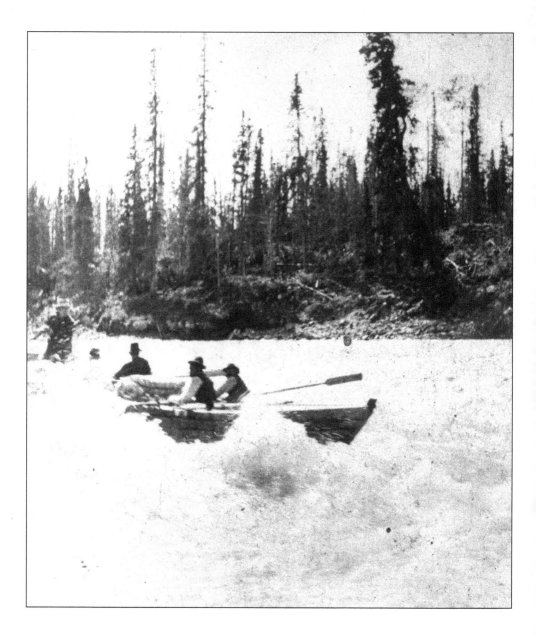

Wild waves rocked and rolled our boat and occasionally broke over us. The spray rose so thick and high we could not see the shore, the very air seeming a sea of misty spray. It was simply glorious. All too soon we rowed into comparatively smooth yet rapid water. A few more strokes of the oars sent us to the shore and the ride was over, leaving a sensation never to be forgotten.
Emma Kelly, 1899

Above: Boatload of stampeders running Whitehorse Rapids.

Opposite Top: A scow manned by eight men shooting Whitehorse Rapids.

Opposite Bottom: Stampeders drying their supplies after wrecking their boat in Whitehorse Rapids.

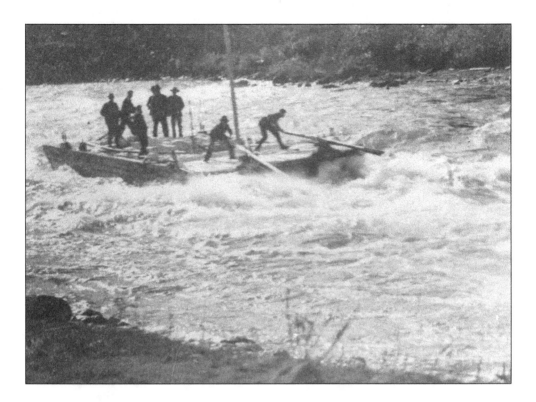

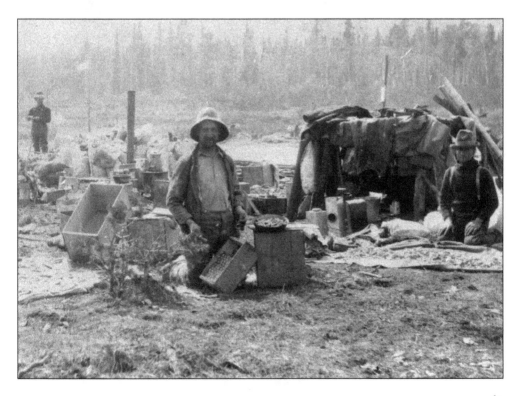

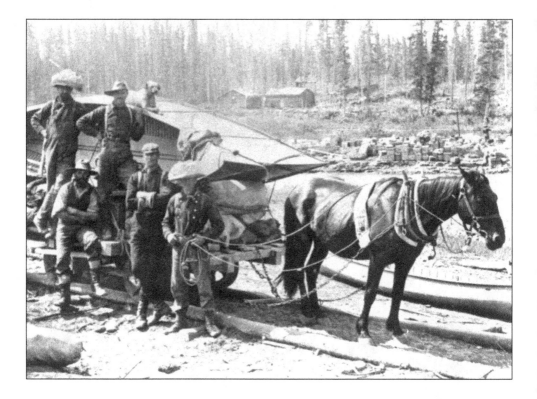

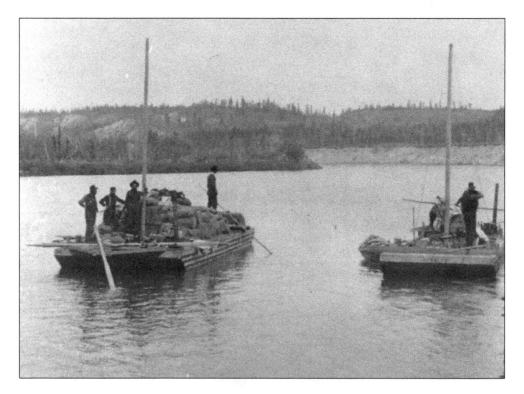

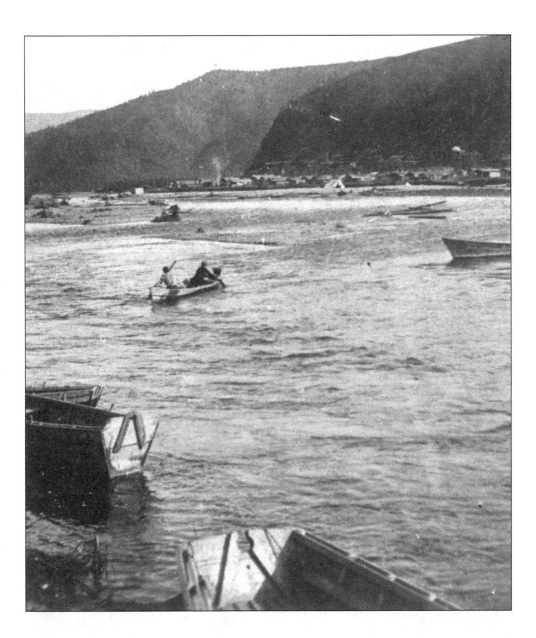

Opposite Top: The tram around Miles Canyon and Whitehorse Rapids was a safe, albeit expensive option for getting supplies safely downriver.

Above: View of the Klondike River with Klondike City in the background.

Opposite Bottom: Two scows loaded with gear freighting down the Yukon River.

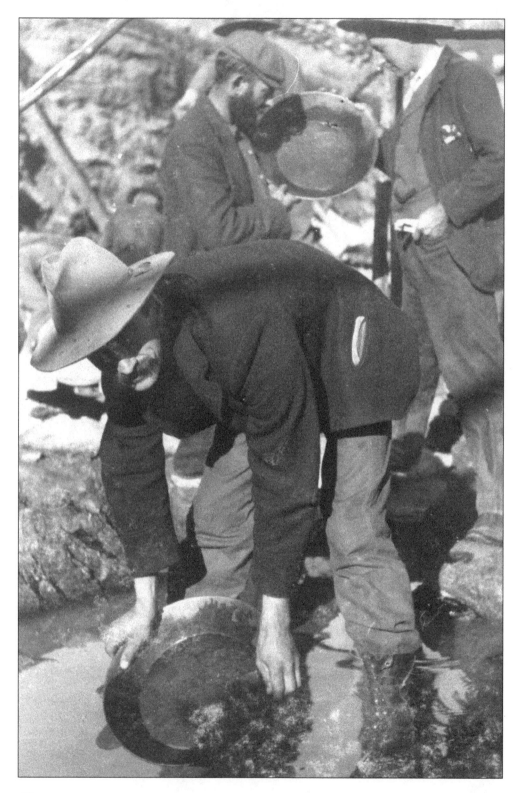

The Creeks

The creeks of the Klondike region were described as being elaborately abundant. Stories outside the Yukon were of gold fields so rich you simply had to bend over and pick up nuggets. And while this was true for some of the richest claims at the start of the gold rush most people had to toil to get their gold.

The lone prospector swishing gold in a pan is the way the gold rush was described in the south. Initially, panning was the predominant means of extracting gold from the sands of the various creeks of the Klondike valley. With time, sluices and rocker boxes were constructed to sift the gravel more efficiently. The only limitation was one's ability to access enough gravel because most of the year the ground is frozen solid.

Many searched for gold by going underground. Claustrophobic tunnels crisscrossed as stampeders searched for a "pay streak." Tunneling in the north is difficult because of the permafrost, a layer of earth which remains frozen throughout the year. Thawing this layer was done by setting large underground wood fires and then winching bucket after bucket of singed earth out of the mine. Once beyond the layer of permafrost, miners used pickaxe, shovel and bare hands to excavate. Candles flickered in the damp, narrow passageways. Most mines were more than thirty feet below the surface, and few went deeper than a hundred feet.

Day laborers could make as much as $15 a day, and many received bonuses and other incentives to work as quickly as possible. They would never get rich, although day laborers often did very well working these claims.

Panning for gold on Bonanza Creek. The vast majority of stampeders never even tried panning for gold.

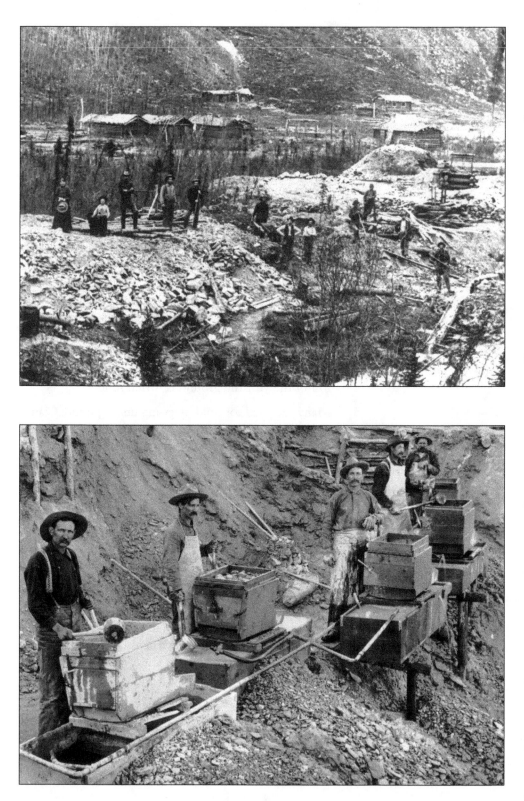

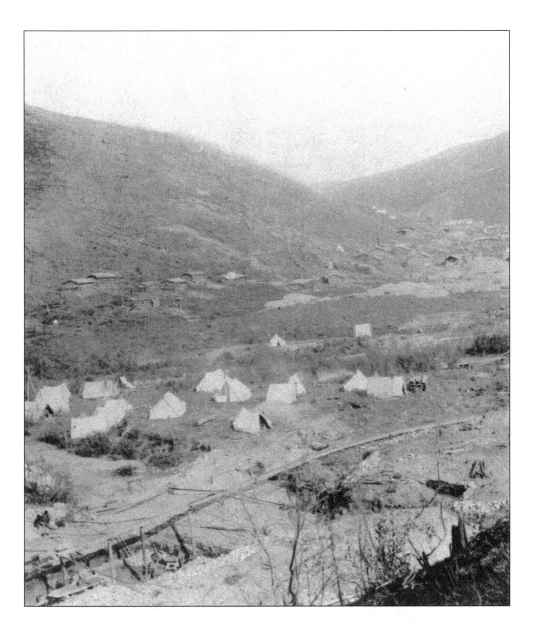

Opposite: Overnight the valley bottoms were transformed by the frenzy of mining activity. Miners worked frantically with shovels and wheelbarrows as sluice boxes have an insatiable appetite for gravel.

Above: Dozens of tents and log cabins line Bonanza Creek.

Men with never a penny to spare in their lives were suddenly made rich. There was no real disorder, there were no shootings, no hold-ups, none of the things associated in the popular mind with a real live mining-camp. Something in the Yukon air discourages all that.
Tappan Adney, Journalist, 1899

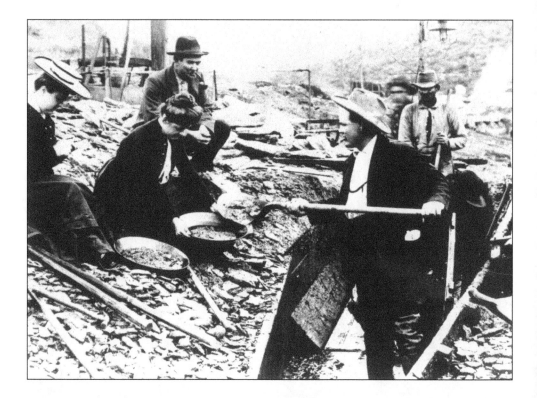

It was hard to believe that this was the spot towards which all the world was looking. Little more than a year ago this wilderness, now peopled by some thousands of white men, resounded only to the wolf's howl and the raven's hollow klonk. Well might one gaze in wonder, whether an old California miner or one who had never before seen men dig gold, for the world had seen nothing like this.
Tappan Adney, Journalist, 1899

Above: Clarence Berry, one of the "Kings of the Klondike," shoveling dirt from claim no.6 on Eldorado Creek, from which he retrieved a fortune to put into the gold pans of waiting women.

Opposite Top: Various pieces of mining, equipment, miners, cabin and pack train in this scene of Cheechako Hill.

Opposite Bottom: Miners loading dirt in are car on gravity train tracks. Flume, steam-thawing, machine, log structures and tents are all visible in the background.

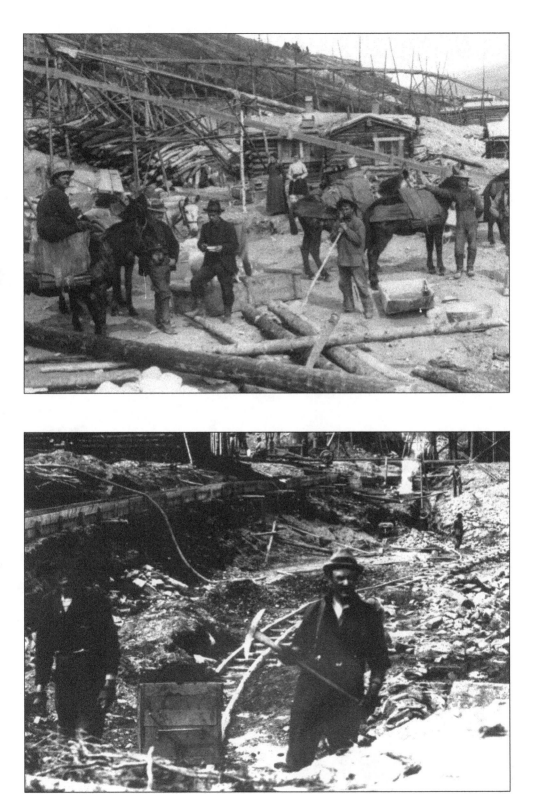

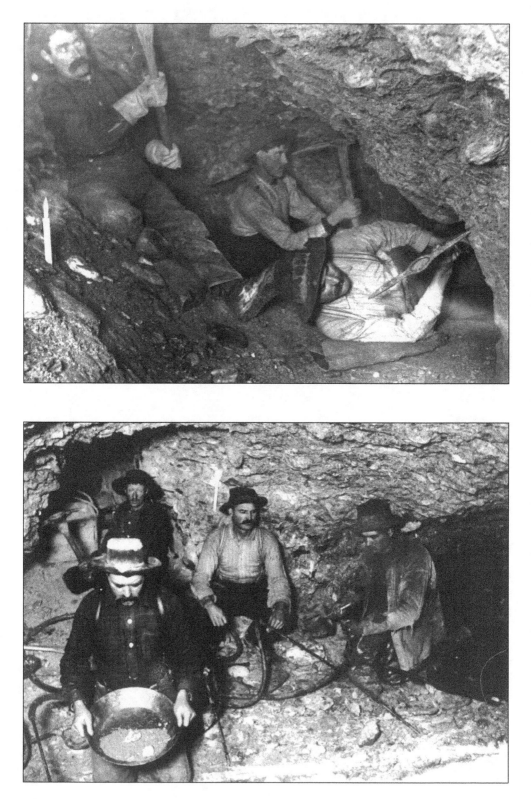

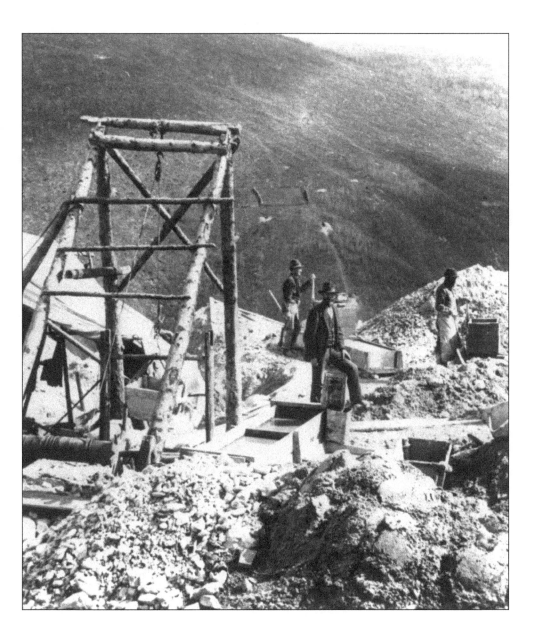

Opposite Top: Underground miners working by candlelight.

Above: Miners working a bench claim on Gold Hill.

Opposite Bottom: Underground miners working with pickaxes; steam-thawing hoses are visible, as is the bucket to haul gravel to the surface. One miner is displaying a pan of pay dirt.

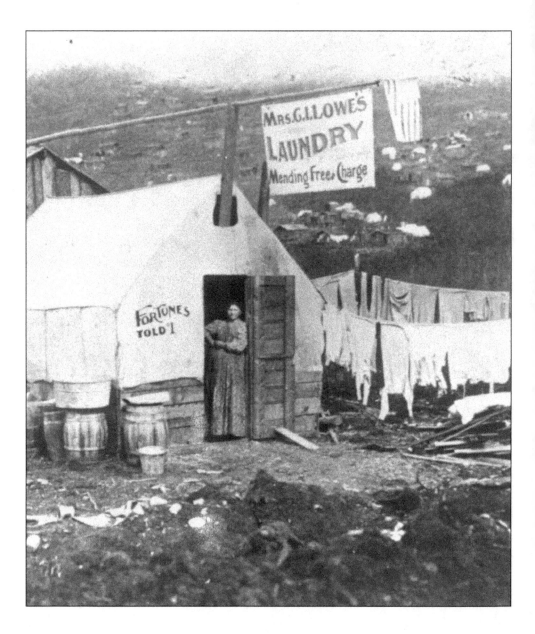

I wanted the gold, and I sought it;
 I scrabbled and mucked like a slave.
Was it famine or scurvy, I fought it;
 I hurled my youth into a grave.
I wanted the gold, and I got it—
 Came out with a fortune last fall,—
Yet somehow life's not what I thought it,
 And somehow the gold isn't all.
The Spell of the Yukon, Robert Service

Above: Mrs. G.I. Lowe's laundry on Bonanza Creek. She also did free mending and told fortunes.

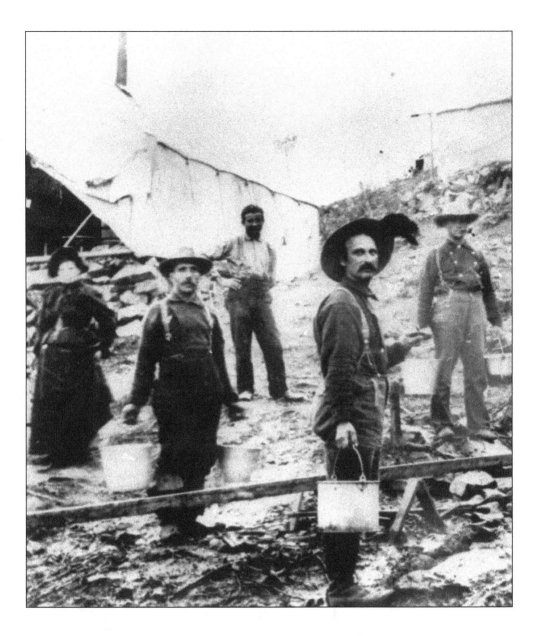

Above: In the Klondike, even simple chores such as getting water were time-consuming.

I took my pan over near the bank, poked around a bit with the shovel, looking for a prospect, and then started digging. All of a sudden the fine gold, looking much like gravel, came rushing down as sugar would pour from a sack if you punched a hole in it.
Edna Berry, 1898

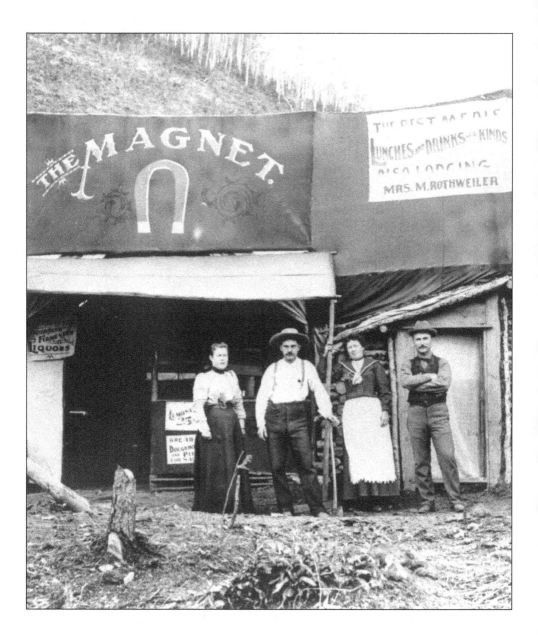

*Above: Belinda Mulrooney's
temporary tent roadhouse "The
Magnet" was opened in the fall of
1898, and was popular for its
liquor and cigars. Mulrooney was a
very successful entrepreneur.*

*Opposite Top: Miners eating at a
traveling lunch counter near
Bonanza Creek.*

*Opposite Bottom: The Bonanza
Hotel, which was built of logs, near
Bonanza Creek.*

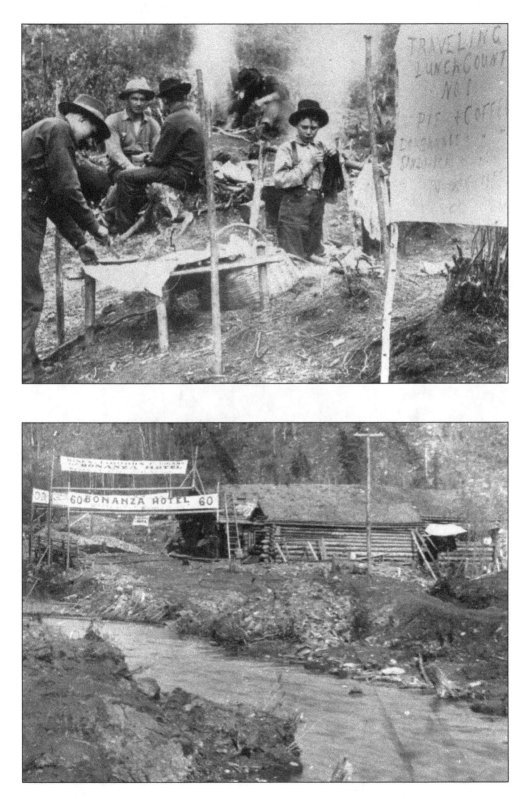

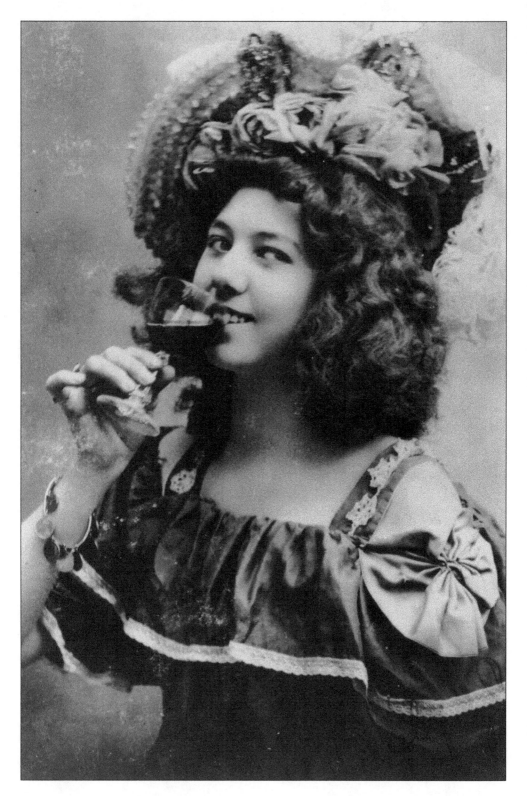

PARIS OF THE NORTH

Dawson sprang almost instantly from the swampy muskeg at the confluence of the Yukon and Klondike rivers. It was a true boom town with a heyday that lasted only a year or two. At its zenith Dawson had a population of more than 40,000 and was the largest Canadian city west of Winnipeg. It was a tent town with numerous clapboard dance halls and saloons.

Most stampeders arrived in Dawson in the spring and summer of 1898. They wandered into this carnival-like town exhausted from their arduous trek. There are many stories of stampeders who upon arriving in Dawson immediately booked passage home, so travel weary and worn-out they did not have any energy to even try to work a claim.

Most of the population of Dawson dined on beans and pancakes. They slept in canvas tents and spent their days in idle anticipation of finding their fortune. They had endured the most arduous and difficult experience of their life just getting to the Klondike valley. Now they were idle with little opportunity to stake or even work someone's claim.

The irony of the Klondike Gold Rush was that the gold fields had been almost entirely staked the year before the stampeders arrived. There was little opportunity for day laborers and many stampeders were flat broke. Dawson was a boom town where the fabulously rich and the dirt poor walked the same wooden planks over the marshy streets. Despair was everywhere except in the dance halls, saloons and shops.

Portrait of "Klondike" Kate Rockwell, an entertainer who was popular in Dawson.

For a brief moment Dawson was the 'Paris of the North' and had a range of goods and services that haven't been seen since. In Dawson you could buy the best champagne and sip it in fine crystal. You could dine on filet mignon, oysters and caviar. Fine silks, jewelry and gowns were available for a price. Virtually anything was possible in Dawson.

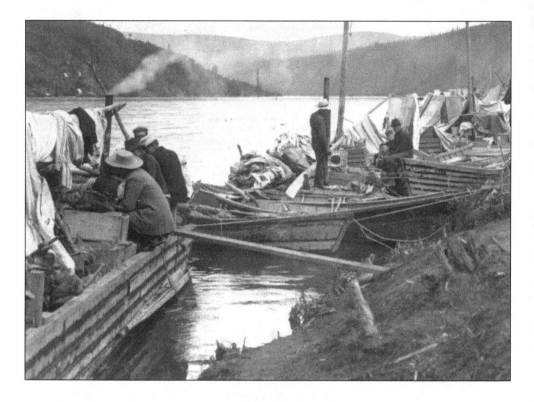

It was a town of rich contradictions. The North West Mounted Police maintained a close rein on the town. The police freely sentenced people to the police barracks woodpile or, in the case of more serious offenses, banished the convicted from the Klondike valley. Prostitutes could pursue their trade openly, and gambling halls held freedoms beyond anything seen on the continent. On the other hand, certain laws were enforced with great fervor. For instance, carrying guns was strictly forbidden and may have been the reason there was not a single murder in Dawson during the first hectic summer. On Sundays and certain holidays the town came screeching to a halt. Every saloon, dance hall and casino closed their doors from midnight Saturday until midnight Sunday. In the midst of the chaos Dawson was silenced. Work of any kind was not permitted, and more than one person was fined for chopping wood on Sunday.

Above: Boats and barges line the shore of the Yukon River at Dawson.

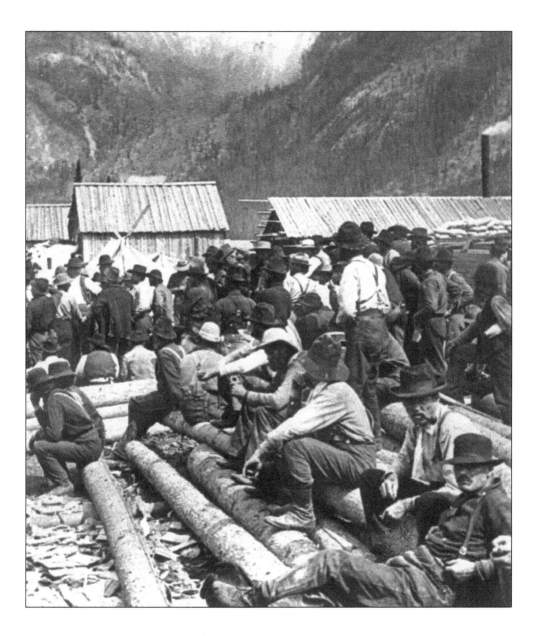

Above: A crowd of stampeders
gathered along the riverbank.

There are many men in Dawson at the present time who feel
keenly disappointed. They have come thousands of miles on a
perilous trip, risked life, health and property, spent months of
the most arduous labor a man can perform, and with
expectations raised to the highest pitch, have reached the
coveted goal only to discover the fact that there is nothing here
for them.
The Klondike Nugget, June 23, 1898

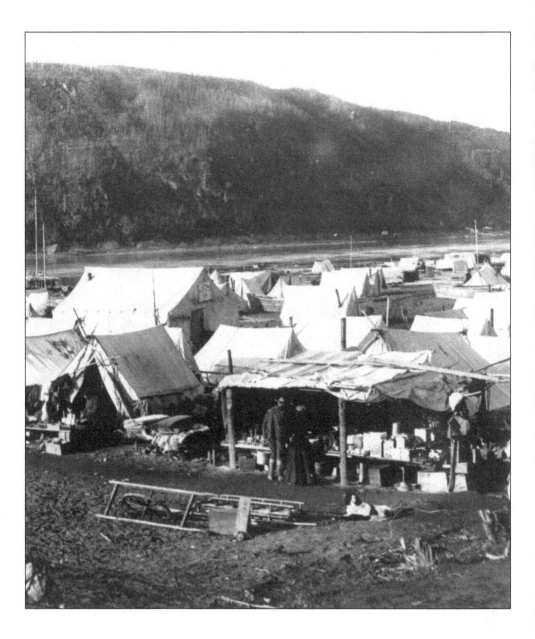

Above: "Bowery Street" was the name given to this area along the Yukon River inhabited by tent dwellers. Merchants have their wares displayed under canvas awnings.

Opposite Top: Panorama of "Tent Town" in the spring of 1898.

Opposite Bottom: Meals tended to be simple and repetitious for most stampeders.

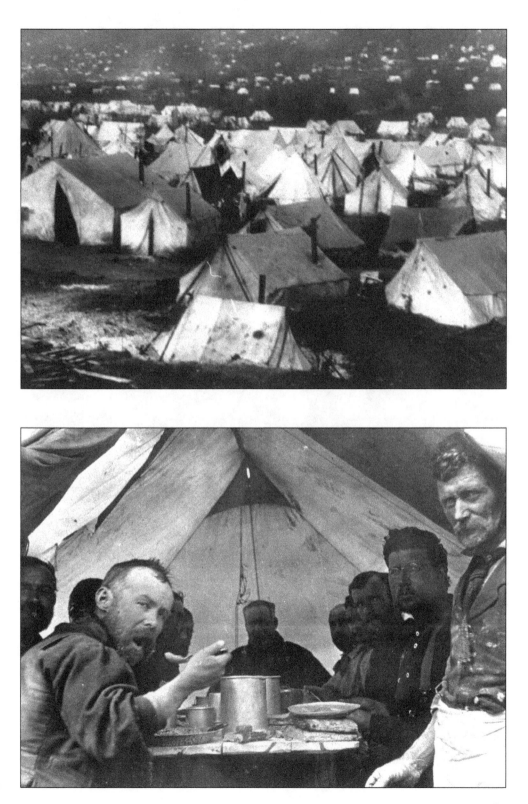

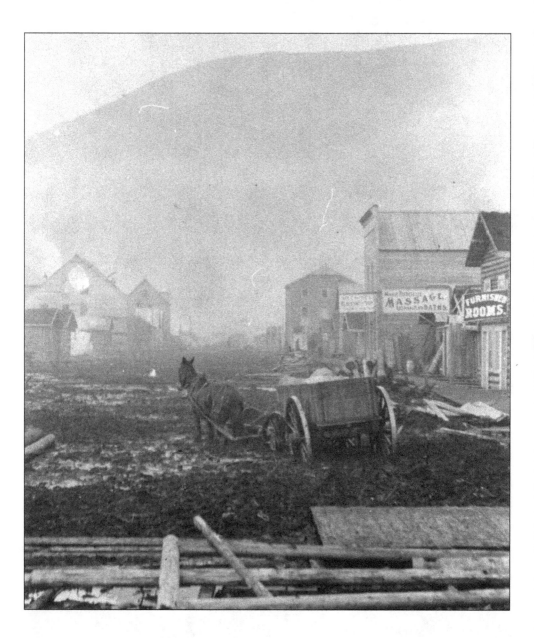

The town was the most unsanitary place imaginable. I know a man who made a bet that he could go down the main street and travel the whole way jumping from one dead horse to another or to a dead dog, and he won his bet. The latter part of the summer typhoid began to rage and there were often eight or ten deaths a day.
Arthur T. Walden

Above: Horse and cart stuck in the mud on Second Avenue. Dawson was built on a swamp, and after a hard rain some of its streets became impassable.

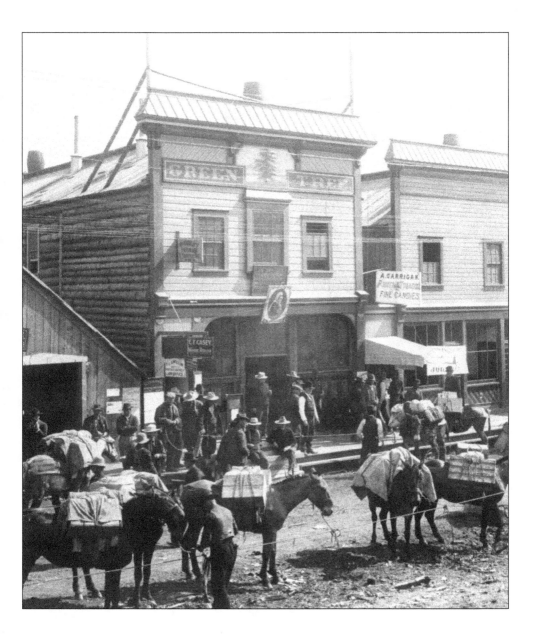

Above: Pack trains were used extensively to haul supplies around town and to the creeks.

At Dawson buildings of every description sprang up like mushrooms in a night, from the black, reeking bog. Many of them were of substantial logs and lumber, but the greater part, both large and small, were mere coverings, intended to last only through the summer.
Tappan Adney, Journalist, 1899

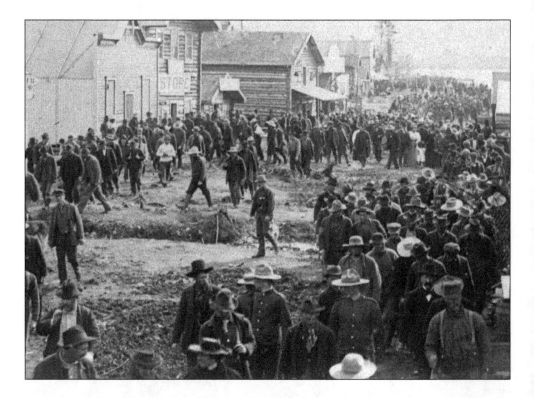

It was with the wildest enthusiasm the large American population of Dawson welcomed the advent of the Fourth of July. Scarcely had the watch ticked a few seconds after midnight on Sunday when a regular fusillade of pistol shots broke the Sunday stillness, and noise and lots of it became the shrill order of the hour. With hoarse "whoops" and "hellos," every loyal sleeping son of Jonathan jumped from his cot and joined in the general racket.

The Klondike Nugget, July 1898

Above: July 4th celebrations of Independence Day were observed in Dawson as most stampeders were US citizens.

Opposite Top: Panorama of Front Street.

Opposite Bottom: Receiving mail was an event for a city filled with homesick stampeders.

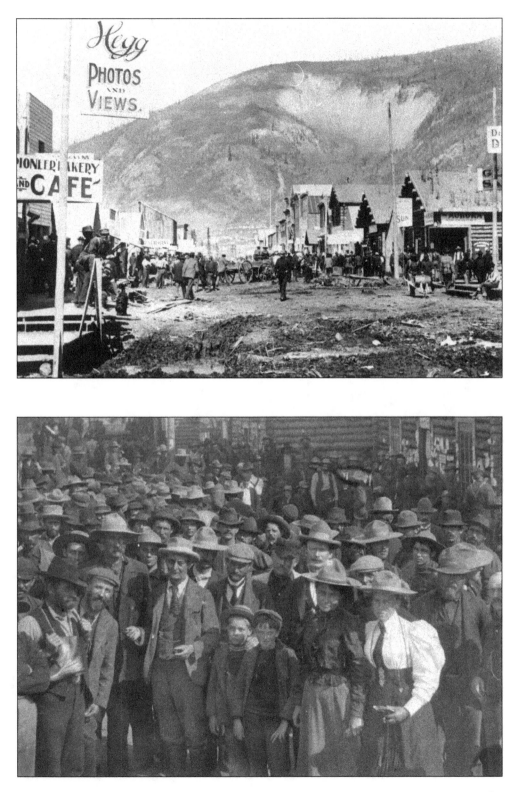

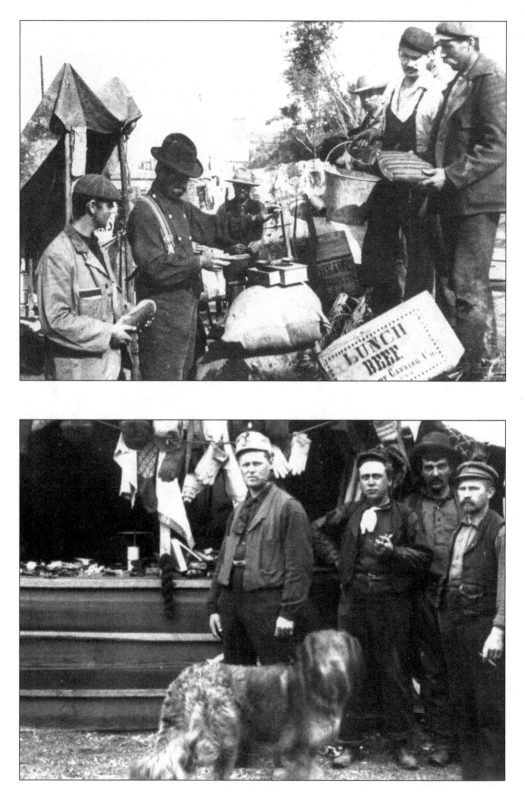

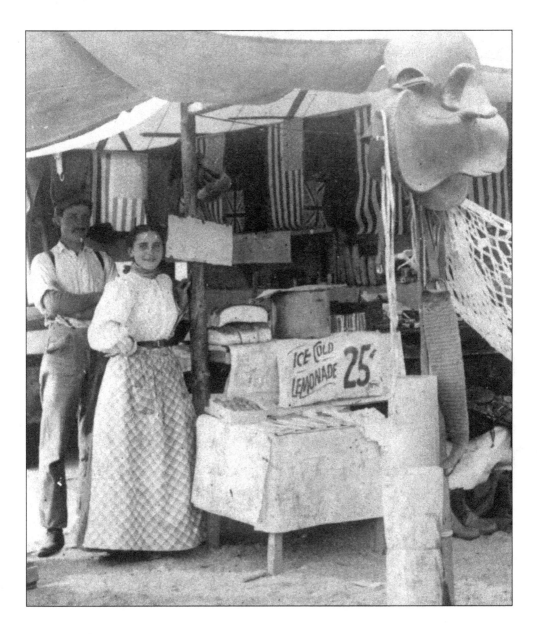

Above: A tent store specializing in fresh lemonade. Stores such as this could earn their proprietors a small fortune.

Opposite Top: A baker exchanging gold dust for bread. Gold dust was an accepted currency in Dawson.

Opposite Bottom: Many stores were housed in tents.

R.G. Gandolfo, a pioneer in nearly every placer or quartz mining camp in the country, and who arrived on the 19th with 16,000 pounds of candies, oranges, lemons, etc., brought the first bananas, cucumbers and ripe tomatoes to Dawson. The bananas brought $1 and the cucumbers $5 each, and at $5 a pound the tomatoes were snapped up as soon as placed on sale.

The Klondike Nugget, July 1898

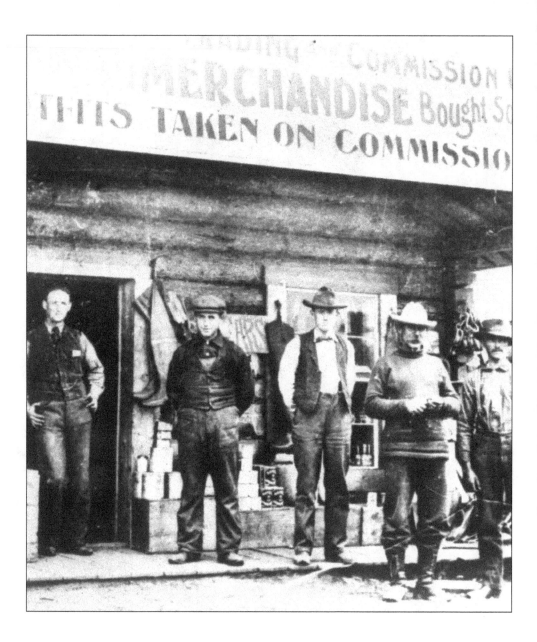

Above: Exterior of a general store which also sold the supplies and equipment of stampeders who decided to return home.

Opposite Top: A market selling wild meat which is hung in front of the store. A slaughtered bear is prominent on the left. Local wildlife populations were decimated.

Opposite Bottom: Waffles were popular in Dawson and numerous restaurants offered them.

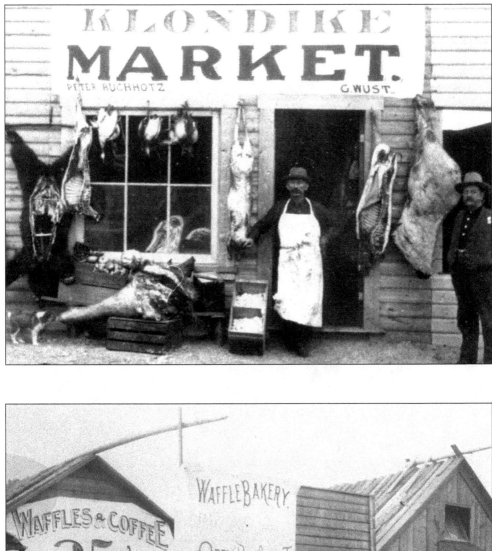

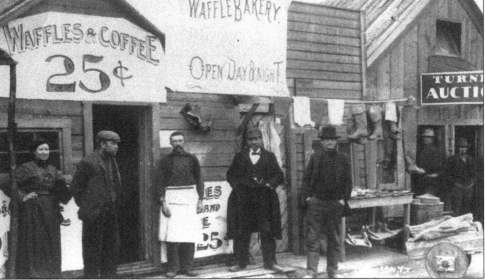

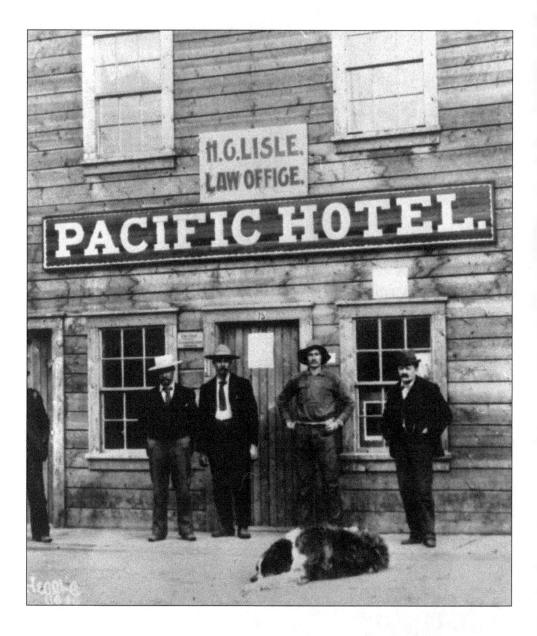

Above: Exterior of the popular Pacific Hotel.

The first milk cow ever in Dawson arrived on Wednesday. She was not very well pleased with her surroundings and did not give much milk; but that first milking brought just $30 in Klondike gold dust. She will be treated to the best that Dawson affords—flour and packing case hay.
The Klondike Nugget, July 1898

Opposite Top: Men gathered in front of the Eldorado House.

Opposite Bottom: Exterior of Great Northern Hotel.

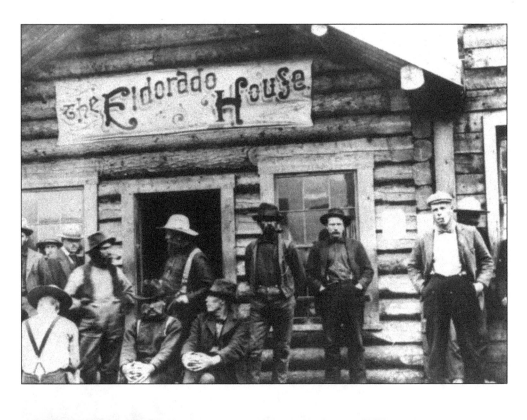

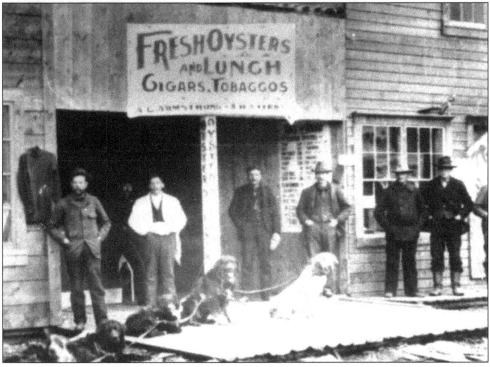

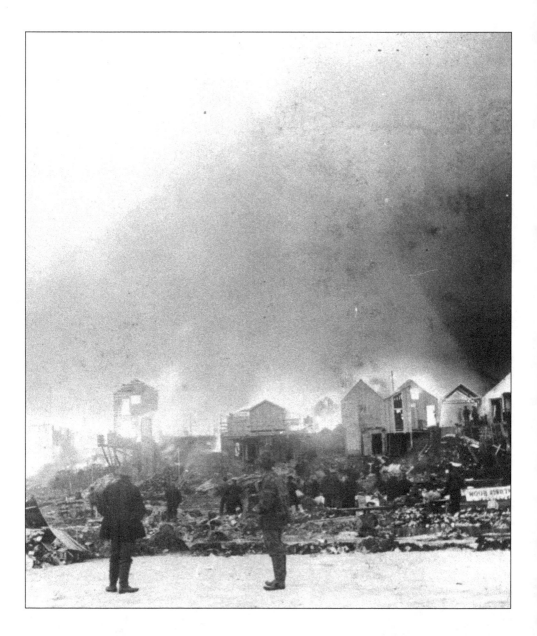

Nothing was saved, and the outfits of ten men were destroyed.
Fire from a similar cause broke out on Thanksgiving evening
and destroyed the opera house and two saloons. Only the snow
on the roofs saved the rest of the buildings on the street.
William B. Haskell, 1898

Above: Cabins and caches are
engulfed by the fire of April 16,
1899. Fires were common in
Dawson.

Opposite: The south face of the
Alaska Commercial Building is
draped in wet blankets as a means
of fire protection. This practice was
common in Dawson.

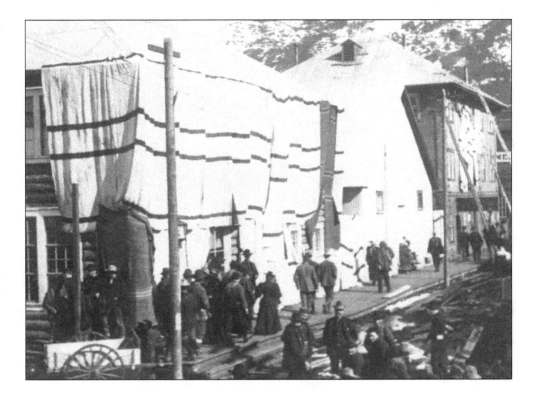

The air was cold and frosty and the inhabitants of the closely
built Front Street were yet for the greater part wrapped in
slumber when in the rear upper rooms of the Green Tree the
flames were first perceived breaking from the windows in roaring
force. The wind was blowing lightly down the river and as Police,
military and citizens thronged to the scene of the conflagration it
was at once recognized that the organized efforts of all could save
the city of Dawson from total destruction. The post office was in
the next building south. Letters were hurriedly bundled into sacks
and waiting hands bore them away. An effort was made to
remove the newly built boxes and pigeon holes and some of the
sections were removed before the fire was seen to have taken the
building. In 10 minutes from the time it took fire, it was falling
to pieces, and so fierce was the fire in 20 minutes everything was
on the ground.
... Then the fire spread three ways, up the street, down the street
and from cabin to cabin on Paradise Alley towards Second
Avenue.... What little water could be secured from the rear of the
fire area was used in sparing quantities to dampen blankets,
sheets and whatever cloth could be hastily drafted into service to
hang over the eaves of the buildings and out the upper windows.
The Klondike Nugget, October 1898

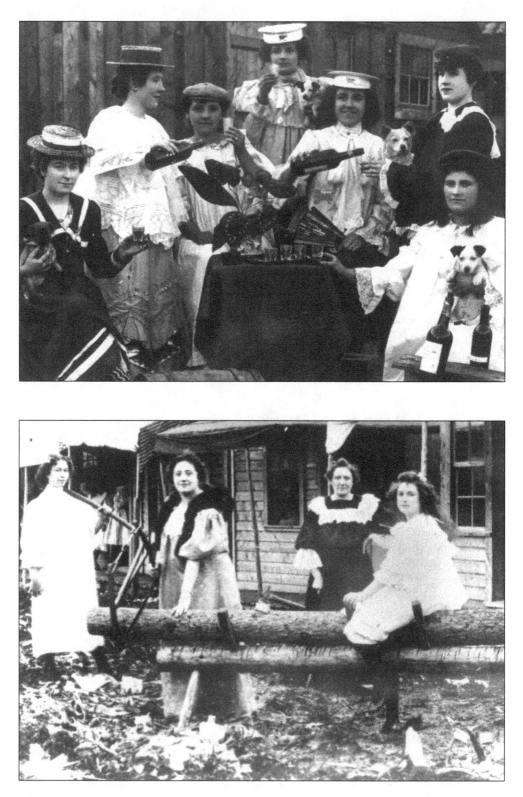

Above: A prostitute awaiting the arrival of prospective clients.

Opposite Top: Prostitutes, holding puppies, gathered for a "drinking bee" in the White Chapel district of Dawson.

Opposite Bottom: Prostitutes in front if their houses if business.

Men who had stumbled over the rough trail in September, poor and disheartened, disgusted with their condition and sick of the country, came down in the spring as millionaires and threw their gold dust about like so much grass seed.
William B. Haskell, 1898

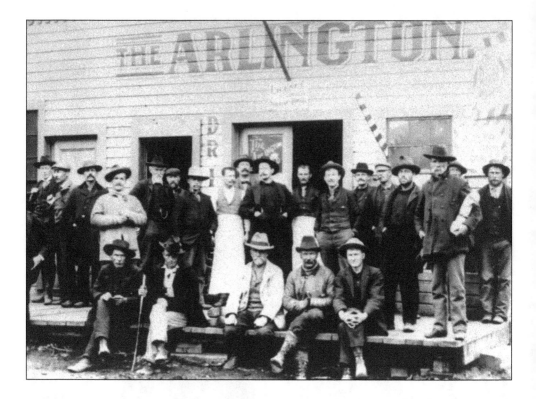

Dawson is probably the only mining center in the world which is a Sunday closing town. Work of any kind is prohibited and all boisterousness on the streets is quickly stopped by the police. Those who have been drunk for a week and gone six days minus sleep are given a chance to sober up and get in condition for another week's run. When the two hands stand on the 12 on Sunday nights, there is merrymaking and the rest of the night reminds one of a brewer's picnic back in the States.
The Klondike Nugget, June, 1898

Above: Arlington Saloon on Front Street.

Opposite Top: Interior of the Monte Carlo Saloon.

Opposite Bottom: Pavilion Saloon on King Street.

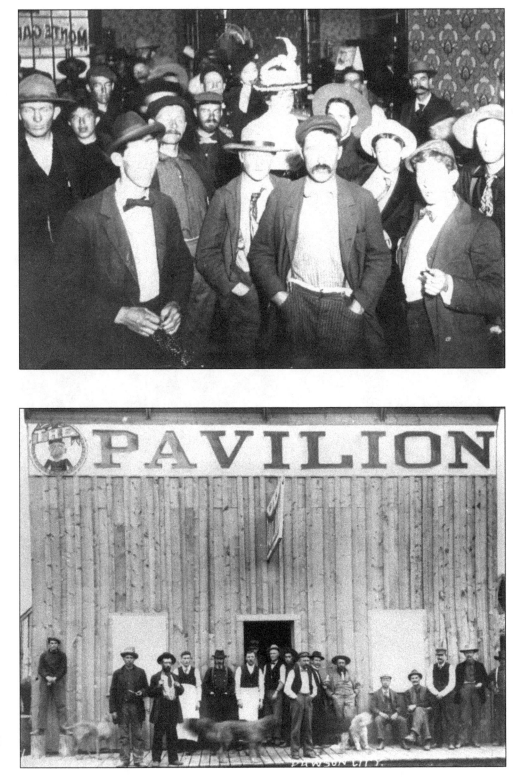

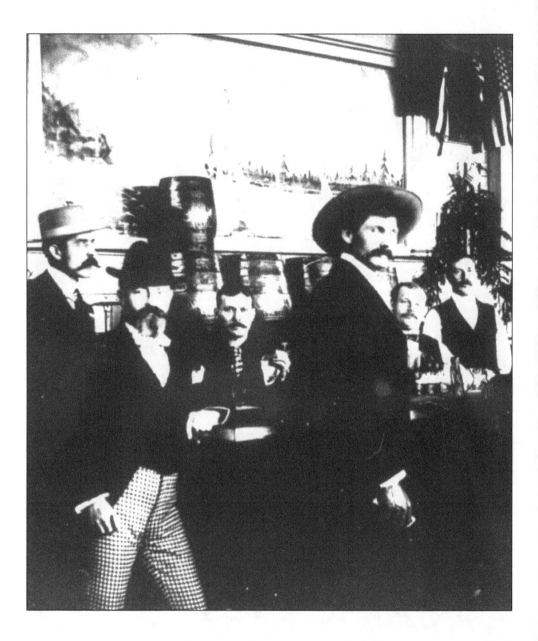

... whole saloonfuls of men would be asked up to drink, at half a dollar a drink. Sometimes orders were given to call in the town, and then the bartender would go out into the street and call everybody in, and all would have to drink. Whenever one of the new "millionaires" was backward in treating, which was not often, the crowd—always a good-natured one—would pick him up by the legs and arms and swing him like a battering ram against the side of the house until he cried out "Enough!"
Tappan Adney, Journalist, 1899

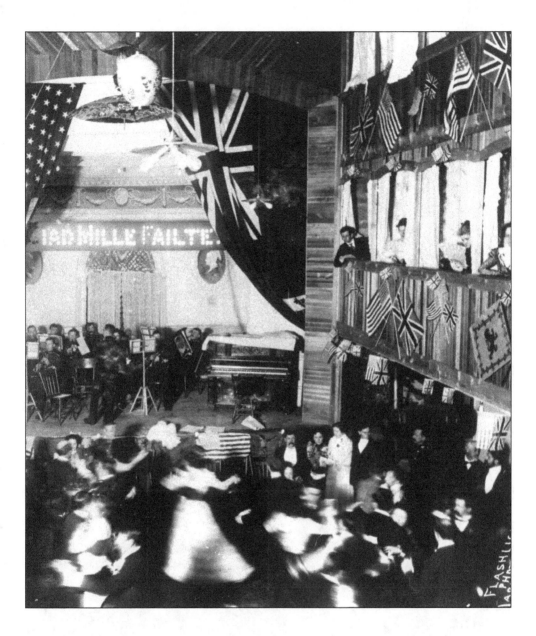

Above: A dance at the Palace Grand Theater in celebration of St. Andrew's night in Dawson.

Opposite: Reopening of the Palace Grand Theater which was destroyed by fire and reopened on July 7, 1899. The man with the wide-brimmed hat and wide-bowed mustache is "Arizona" Charlie Meadows.

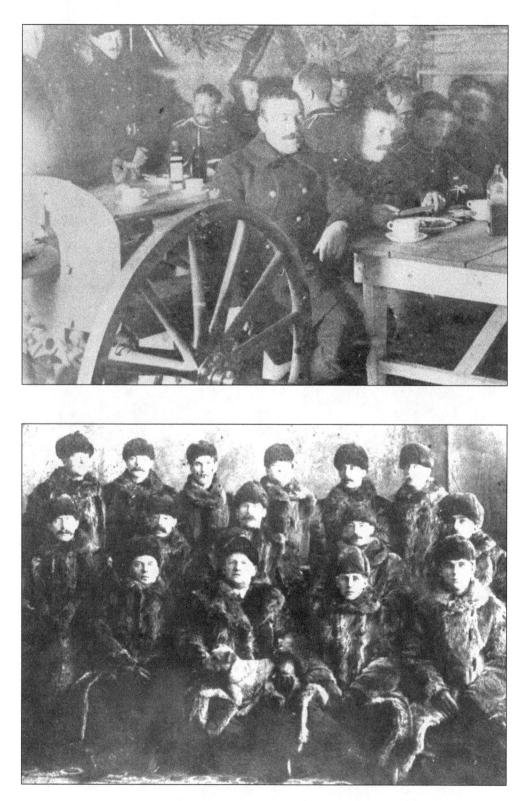

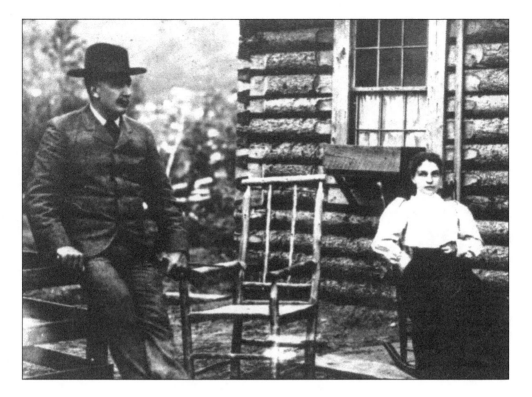

Above: Sam Steele of the North West Mounted Police, pictured out of uniform, earned the nickname "The Lion of the Yukon."

Opposite Top: Members of the North West Mounted Police sitting down to Christmas dinner in the festively decorated mess hall. The Maxim Gun, prominent in the foreground, was brought inside to keep warm.

Opposite Bottom: Fifteen members of the North West Mounted Police in hats and full length fur coats inside the town police station.

My working hours were at least nineteen. I returned to rest about 2 A.M. or later, rose at six, was out of doors at seven, walked five miles up the Klondyke on the ice and back over the mountains, visited every institution under me each day, sat on boards and committees until midnight, attended to the routine of the Yukon command without an adjutant, saw every prisoner daily, and was in the town station at midnight to see how things were going.
Sam Steele

It was nothing unusual to see twelve or sixteen men along the
trail loaded with gold from a single claim One 500, 600,
or 800 ounce moosehide sack full of the dust makes an ample
load for a man. The sack is wrapped in cloths, then put into
the packstrap; but many a sack, especially those belonging to
the smaller miners, was carried down in blankets, partly to
make the load carry more softly, and partly to avoid suspicion,
although whenever one observed a blanket dragging hard on
the straps, one could be pretty sure there was gold inside.
Tappan Adney, Journalist, 1899

*Above: Interior of a store with a
man pouring gold dust from a
pouch to be weighed on a set of
gold scales on the counter.*

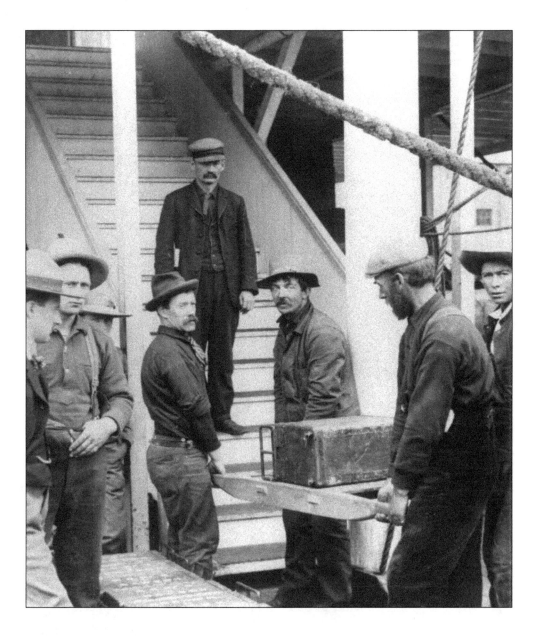

Above: Men loading a gold shipment onto a stern wheeler in Dawson.

Adjutant McGill of the Salvation Army is of the opinion that destitution is increasing in the Klondike.... At present there are 10 men looking for every job and the outlook is for serious suffering unless something turns up.
The Klondike Nugget, May 1899

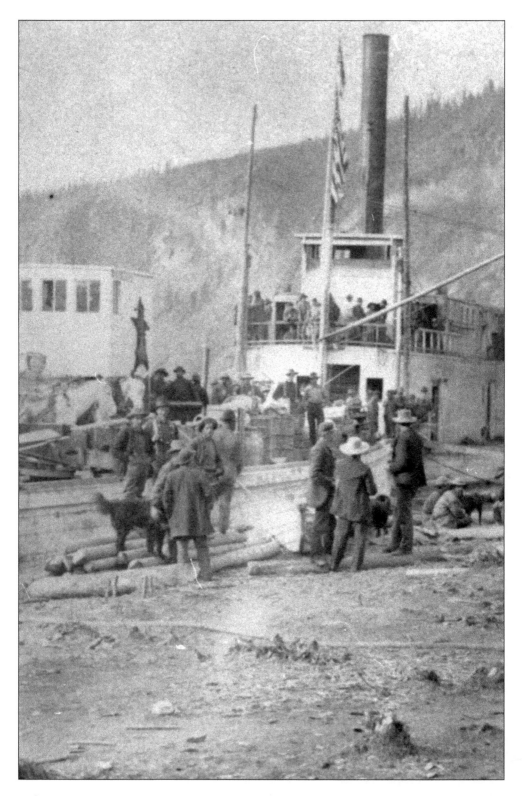

EXODUS

During the late summer of 1899, rumors were circulating of a gold strike at Nome, Alaska. Almost overnight the idle stampeders in Dawson packed their raggedy belongings and started down the Yukon River to Nome. Sternwheelers were oversold as stampeders raced to the new bonanza. Most would leave Nome a few months later, even poorer than when they left Dawson. After Nome there would be small strikes on the Yentna, Susitna and Tanana rivers, but none would come close to the size and scale of the Klondike. A handful of stampeders would follow these echo booms for the rest of their lives without finding any riches .

By the autumn of 1899, Dawson was relatively deserted. Gold was still being mined, but large companies began buying claims from the small independent miners. The rocker boxes and sluices were replaced by enormous dredges. The dredges were less labor-intensive and those who worked them were employees, not owner operators. The Klondike Gold Rush was over.

The vast majority of the stampeders left the Yukon without making a cent. They had experienced one of the most arduous treks imaginable. The stampeders had traveled up the coast in overcrowded and often decrepit ships. They had spent the winter ferrying supplies over the cold and dangerous Chilkoot Pass and had built rickety boats and navigated the lakes and rapids of the Yukon River system. Returning home would present many challenges, but these would pale in comparison to what they had endured. They had experienced the adventure of a lifetime.

The sternwheelers which had carried many people and supplies to Dawson also transported the town to Nome, Alaska. Overnight, Dawson was deserted.

PHOTOGRAPH CREDITS

Alaska Historical Library Collection
17,32,47,56 top, 57, 83.

Anchorage Fine Arts Museum Collection
7 bottom.

B.C. Archives and Records Service
28.

Dawson Museum
7 top.

MacBride Museum Collection
18 top, 23, 36 bottom, 42 and 43, 63 bottom, 70 top, 70 bottom, 93 top, 97, 98 top, 101 top, 104 bottom, 105 top, 106, 108, 111.

National Museum of Canada
4, 46, 77, 90 bottom, 92, 93 bottom, 94, 95 top, 95 bottom, 98 bottom, 99, 100, 101 bottom.

University of Alaska Archives Collection
19.

University of Alaska Fairbanks, Barrett Willoughby Collection
80.

University of Alaska Fairbanks, Levy Collection
58 bottom.

University of Washington
40 and 41, 56 bottom, 79 top, 79 bottom, 90 top.

University of Washington, E.A. Hegg Collection
10, 16,35,44,45 66 top, 73 top, 73 bottom, 74 top, 74 bottom, 76, 82 top, 102, 103.

Washington State Historical Society
24.

Vancouver Public Library Collection
26 bottom, 38, 39 top, 50, 54 and 55,58 top, 59, 62 top, 63, 65 top, 65 bottom, 71,78,84,85 top, 88, 89 top, 91, 96, 112.

Yukon Archives, H.C. Barley Collection
8, 18 bottom, 70 bottom.

Yukon Archives, Chisholm Collection
87.

Yukon Archives, Gillis Collection
36 top, 37, 60, 61 top, 61 bottom.

Yukon Archives, Glenbow Collection
72,104 top.

Yukon Archives, T.R. Lane Collection
52, 64.

Yukon Archives, McLennan Collection
66 bottom, 67, 68, 86, 89 bottom.

Yukon Archives, Bill Roozeboom Collection
82 bottom, 107.

Yukon Archives, Vogee Collection
9, 12, 13 top, 13 bottom, 31, 39 bottom, 51 top, 52 bottom, 75.

Yukon Archives, Winter and Pond Collection
1,14 and 15,20,22 top, 22 bottom, 25, 26 top, 27 top, 27 bottom, 29 top, 29 bottom, 30 top, 30 bottom, 34 top, 48 bottom.

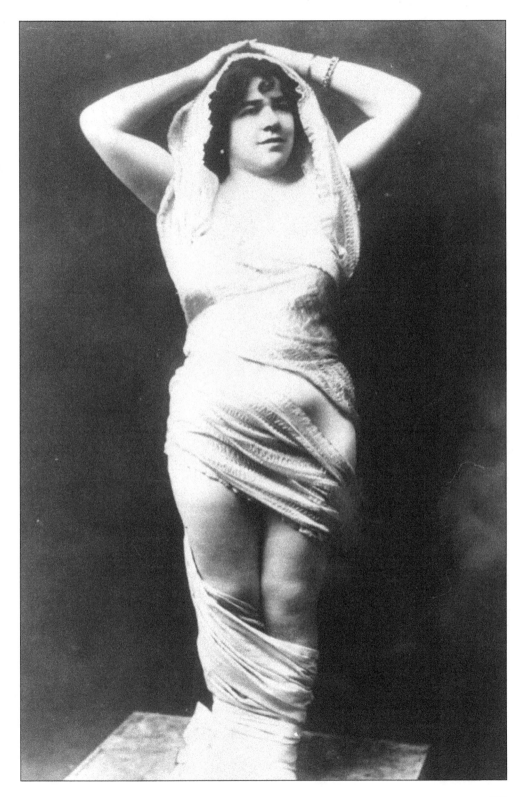

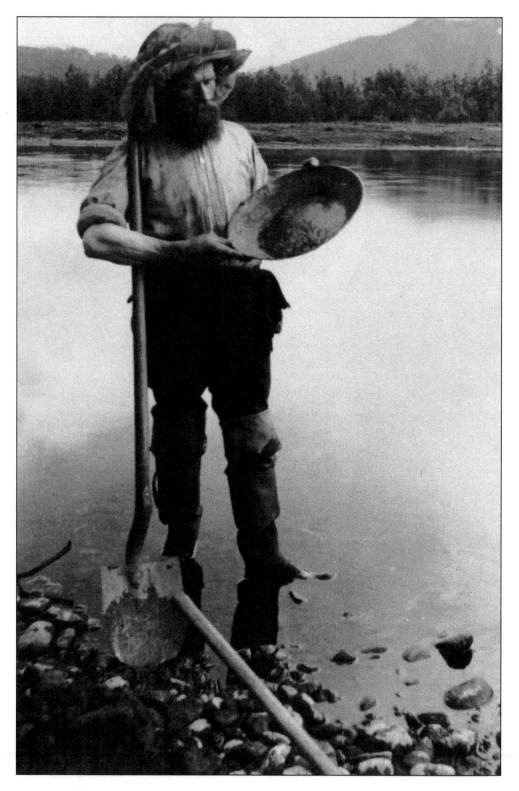